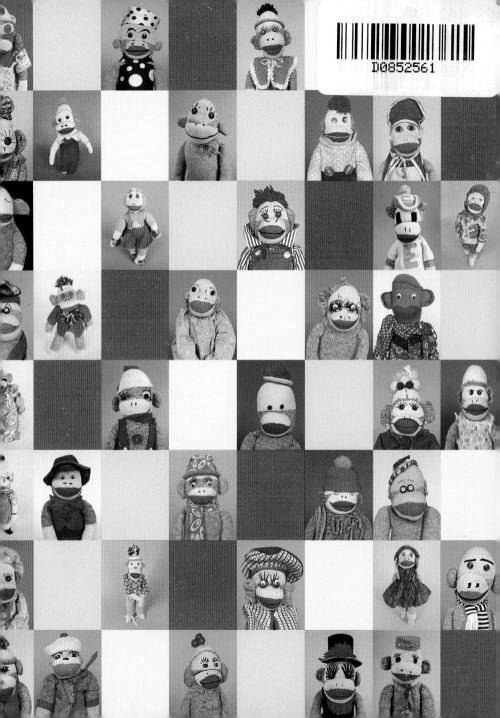

SOCK
MONKEY

teNeues

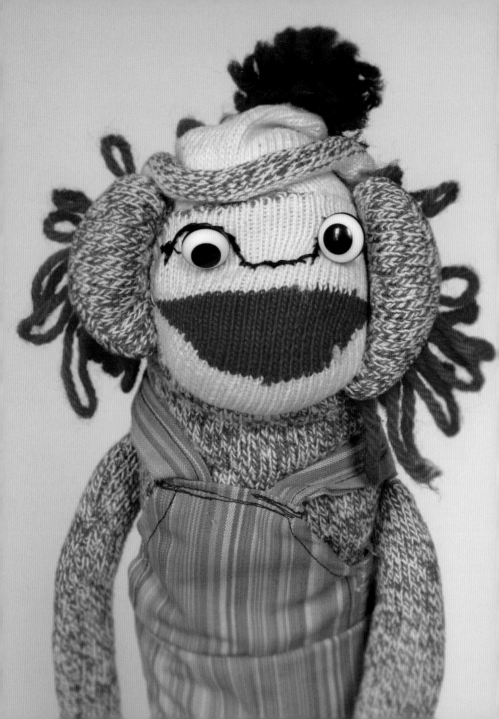

SOCK MONKEY

Arne Svenson & Ron Warren

teNeues

INTRODUCTION

Who knew that two buttons, a pom-pom and a length of thread sewn onto a sock could bear an uncanny resemblance to your aunt Lucille? Or that a pair of socks intended for your grandfather's feet could morph into a stuffed animal whose face and body are absolute ringers for, well, Grandfather?

The sock monkey is a classic American toy, home-crafted from a pair of a distinctive variety of knit work socks. The beloved creatures first started showing up in the arms of boys and girls in the late 1930s and have remained a popular gift for generations of children. There is beauty in the economy of their basic design: each monkey's body is fashioned from one sock, the red heel serving as the rear end and the toe as the head. The red heel is cut from the other sock and sewn onto the first to form a broad red grin.

Variations in the way the socks are cut, stuffed, and assembled result in wildly individualized body types and sizes, ranging from pencil-thin to plus-size XXL and beyond conventional proportions. Colorful outfits and accessories further define and enhance the monkeys' characteristics. But it is the eccentric abandonment with which buttons, beads, appliqué, yarn, and embroidery are applied to the faces that gives each monkey its wonderful, almost human, expression.

We have taken portraits of 950 sock monkeys from Ron Warren's collection of more than 2,000. This leaves approximately 1,050 sock monkeys waiting not so quietly in the wings… Next!

Arne Svenson & Ron Warren

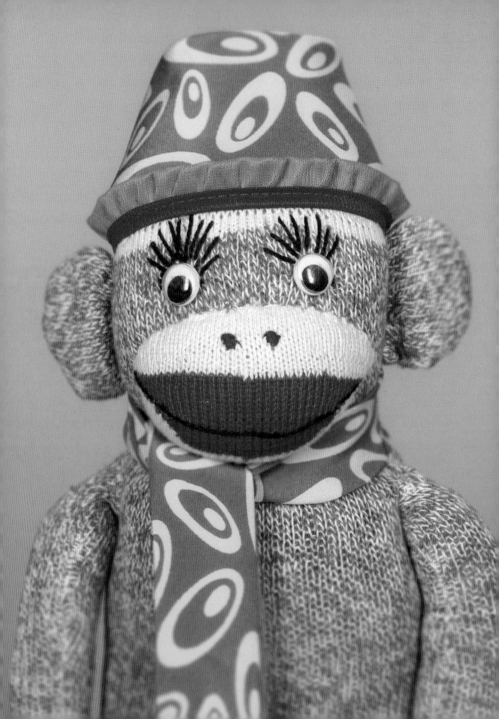

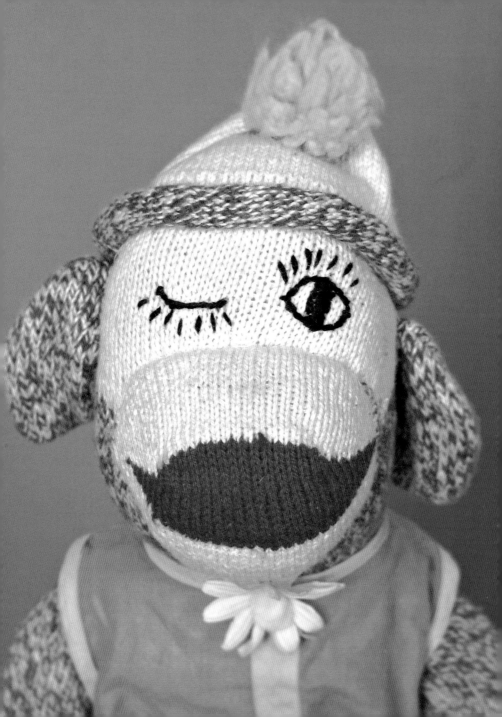

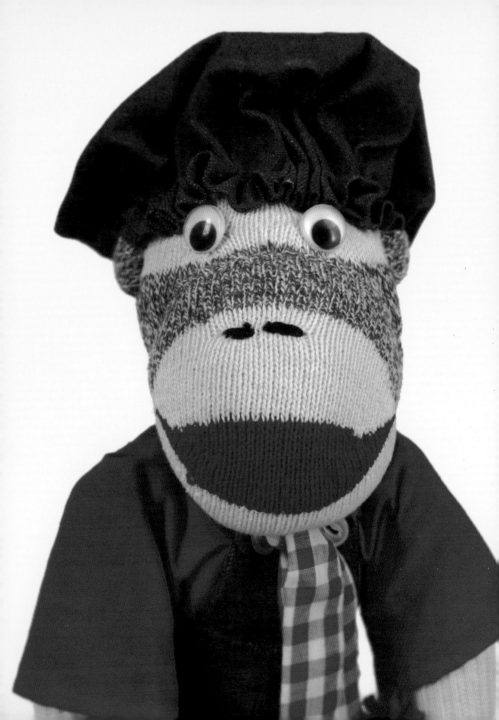

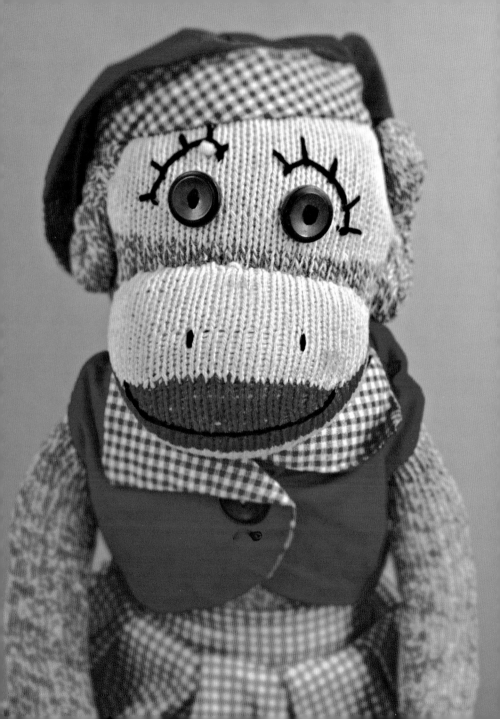

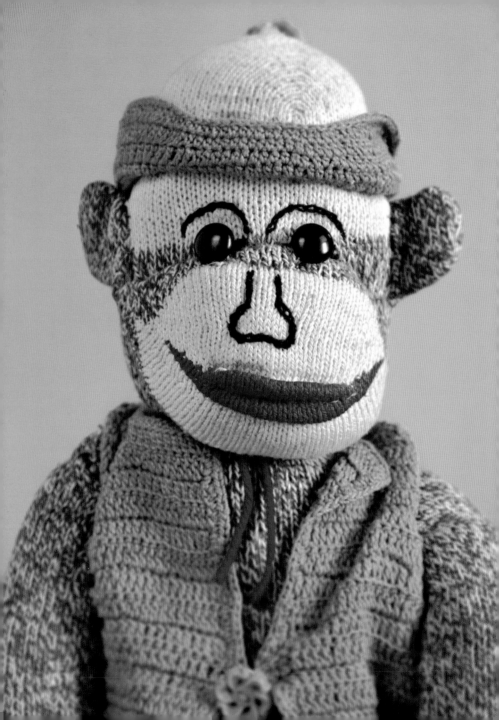

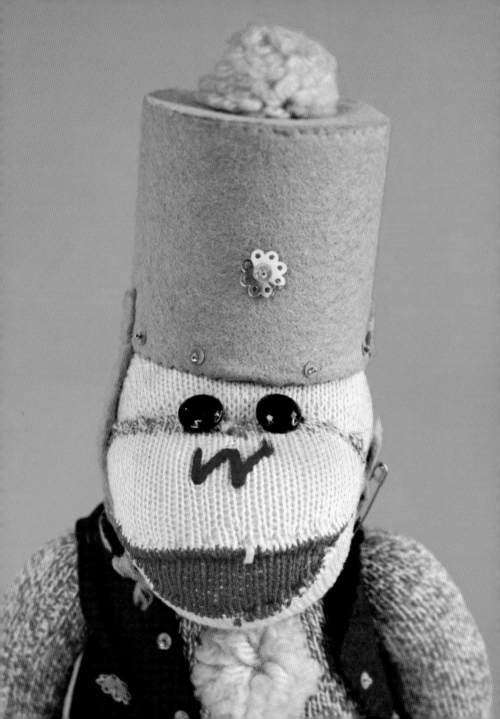

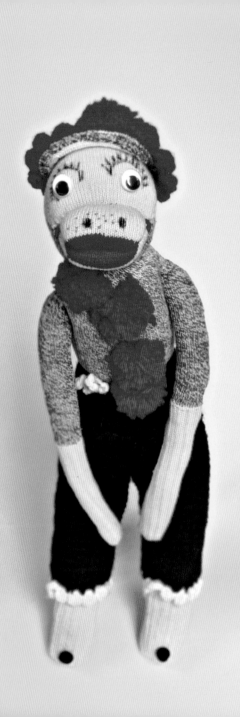
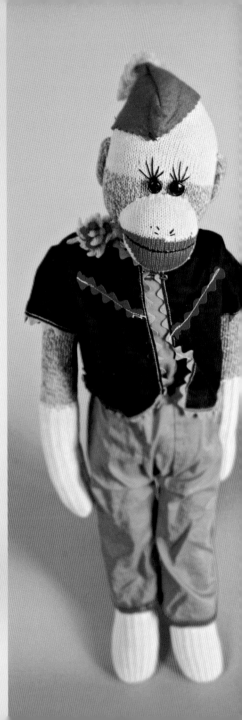

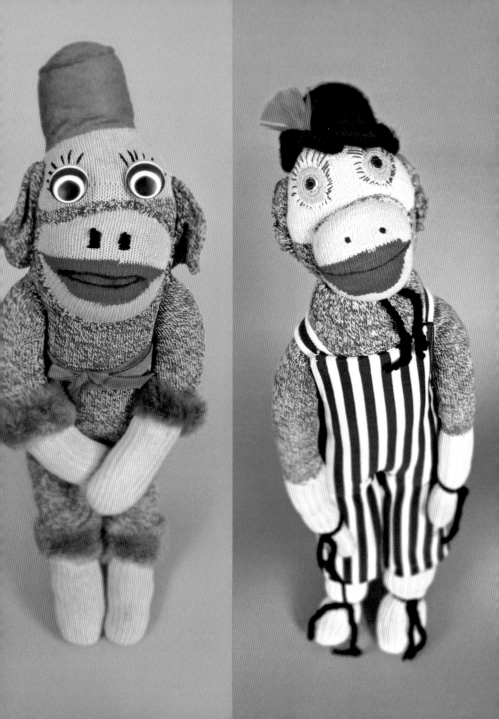

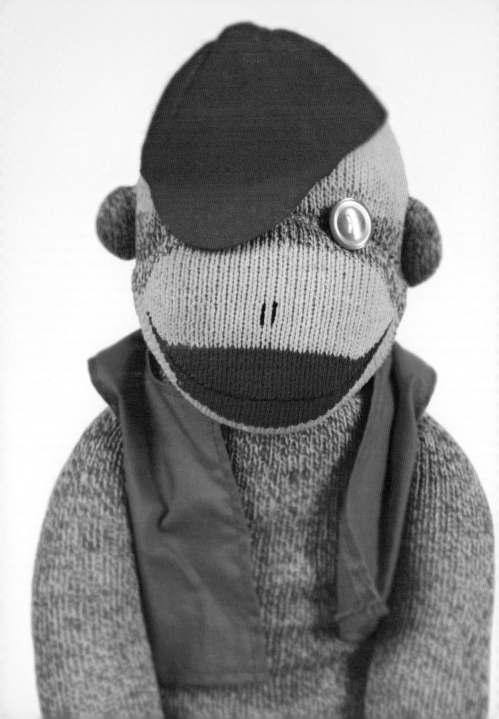

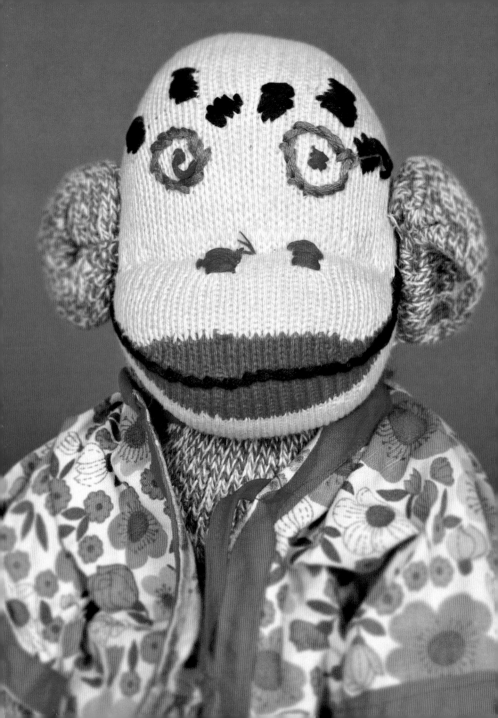

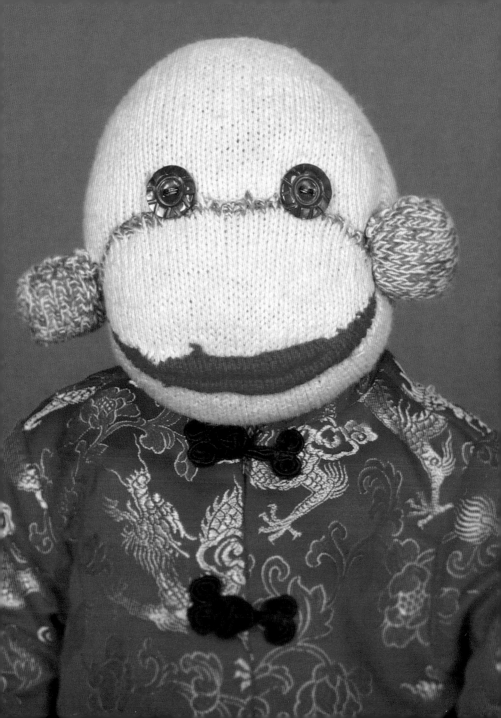

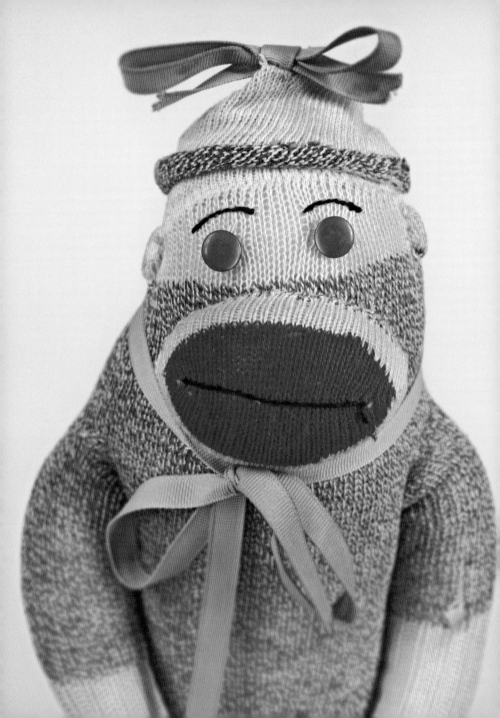

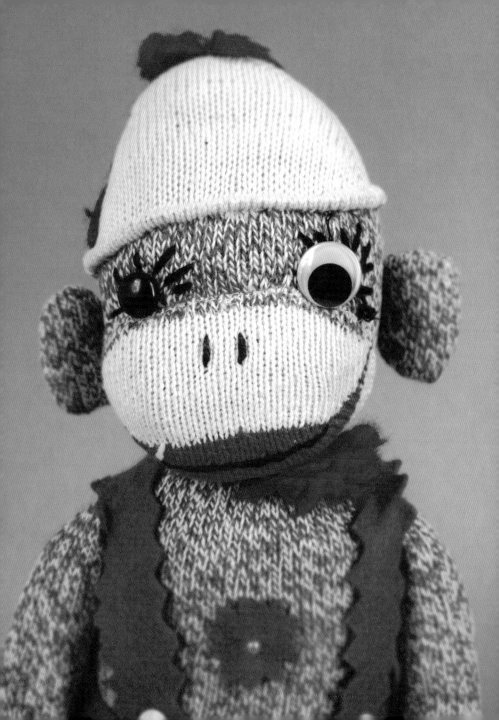

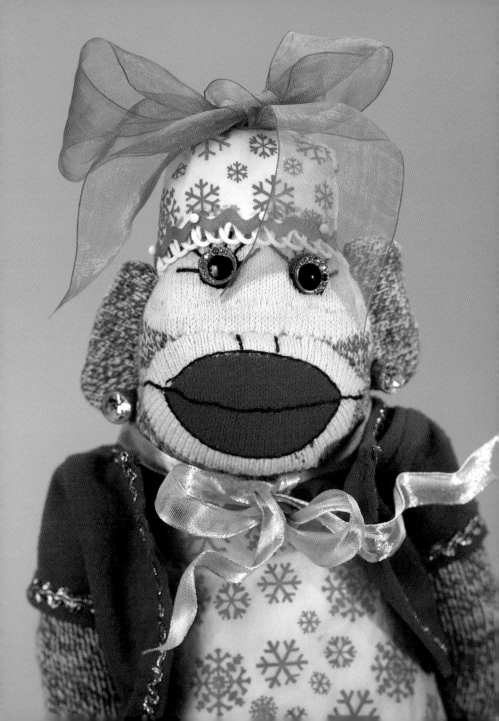

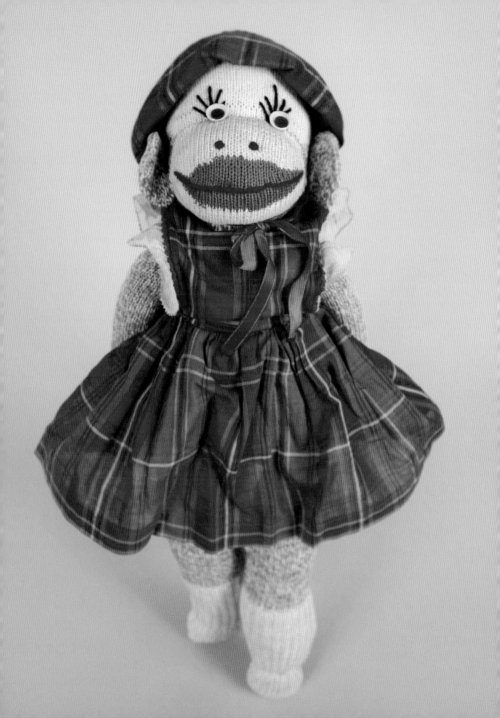

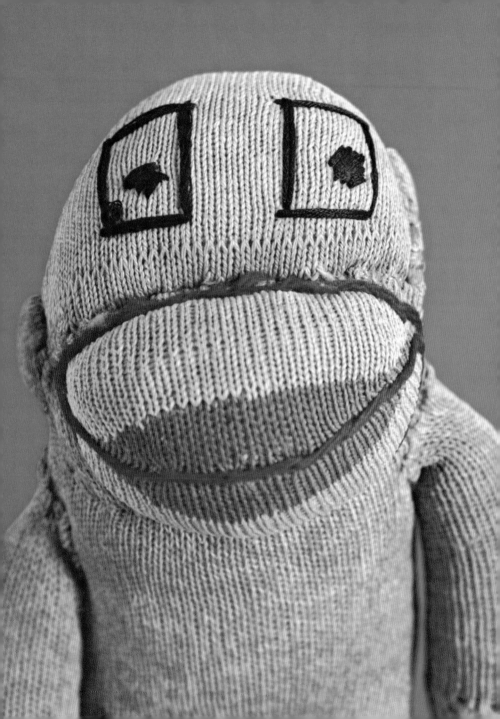

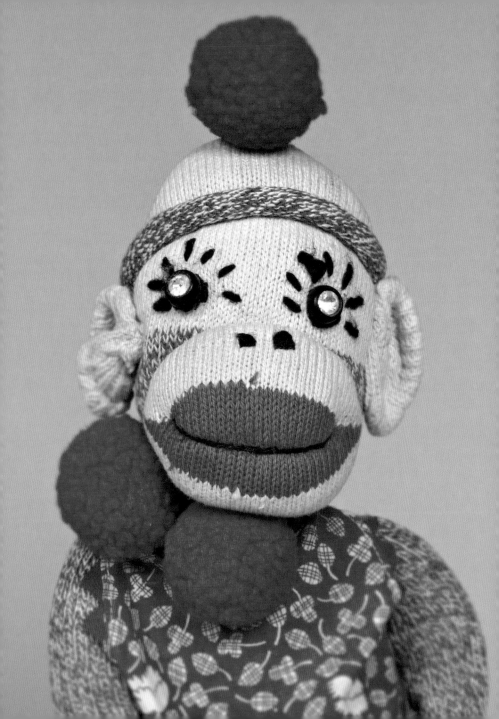

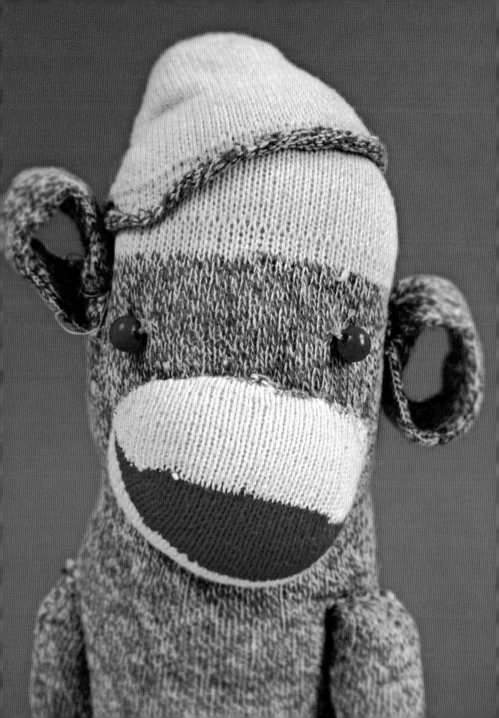

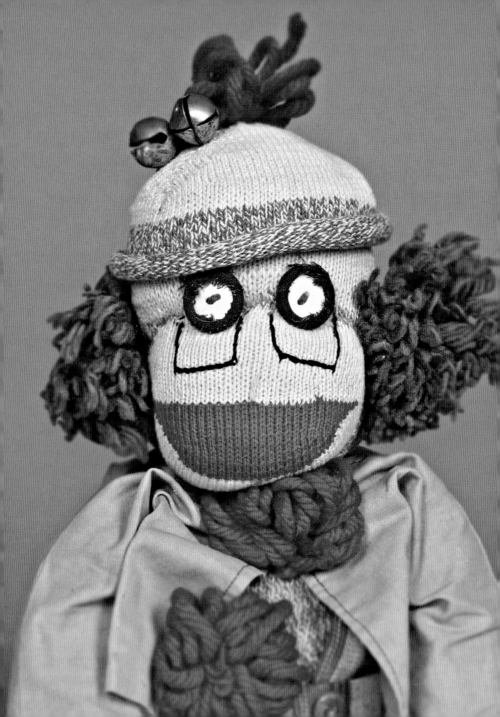

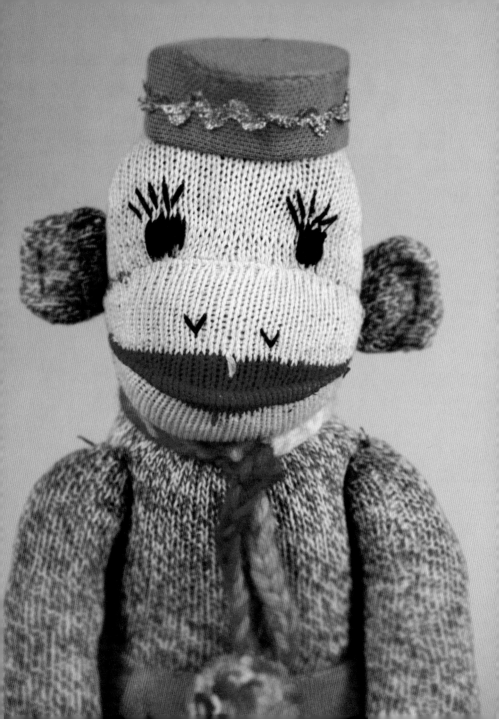

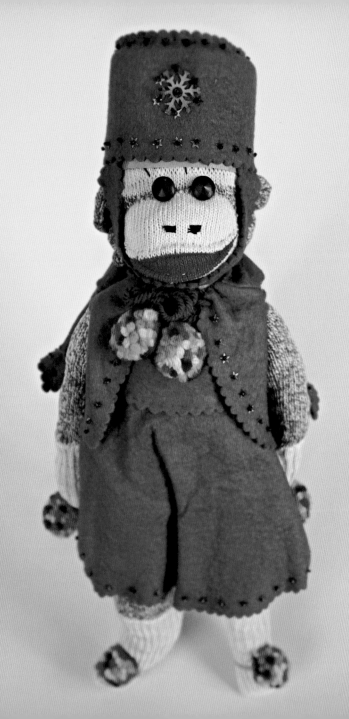

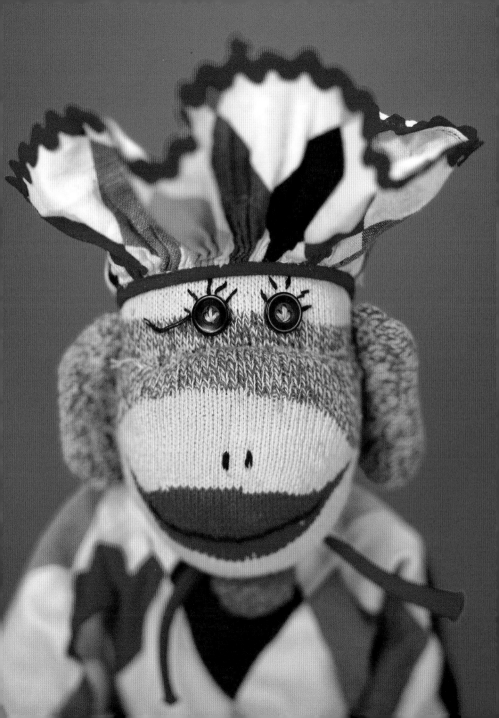

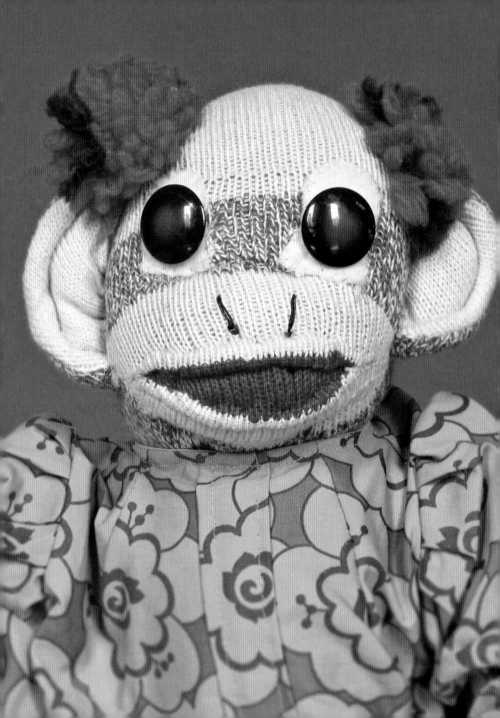

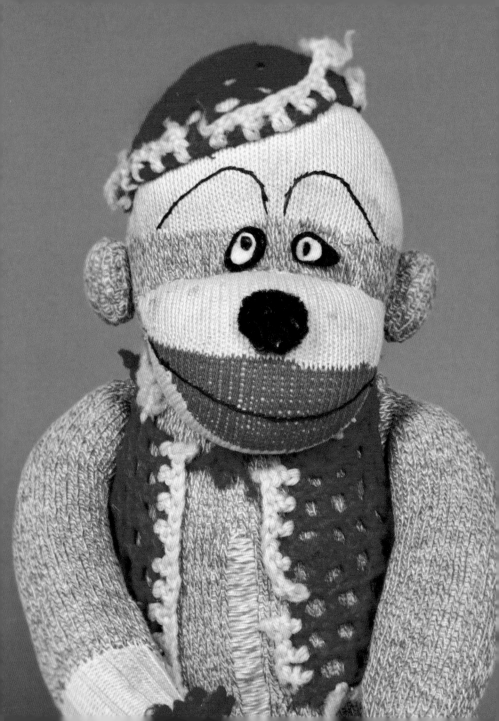

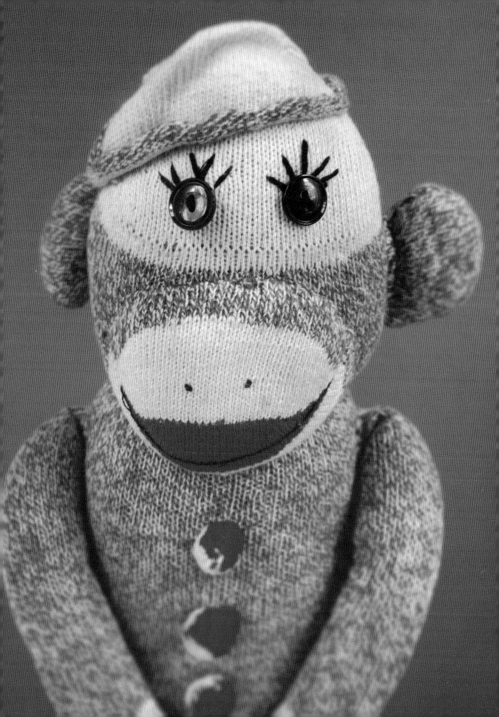

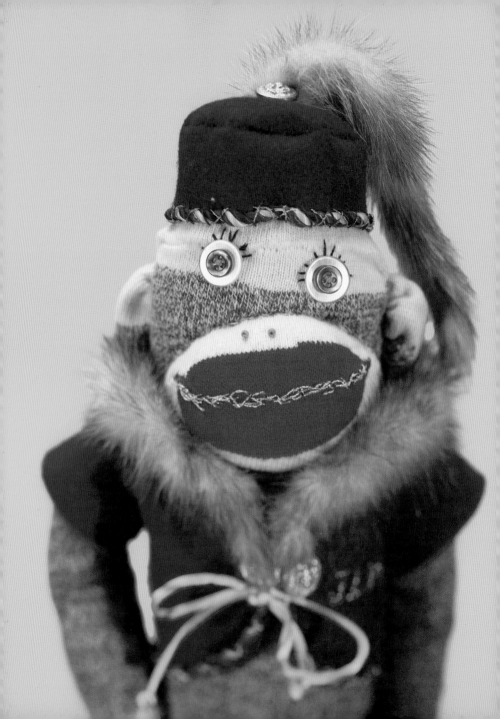

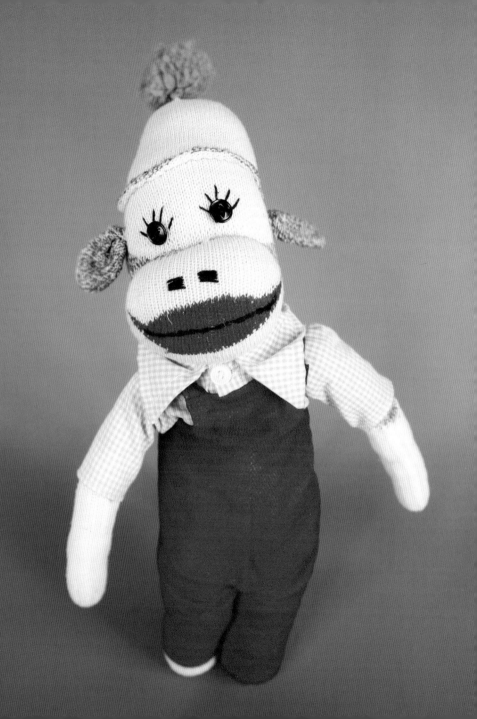

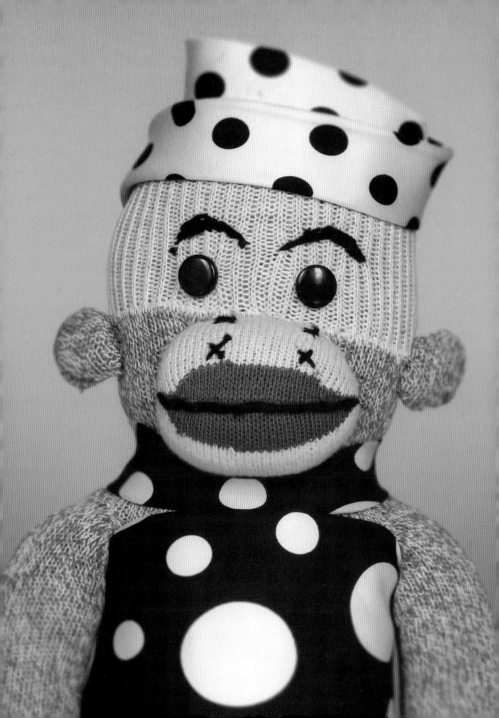

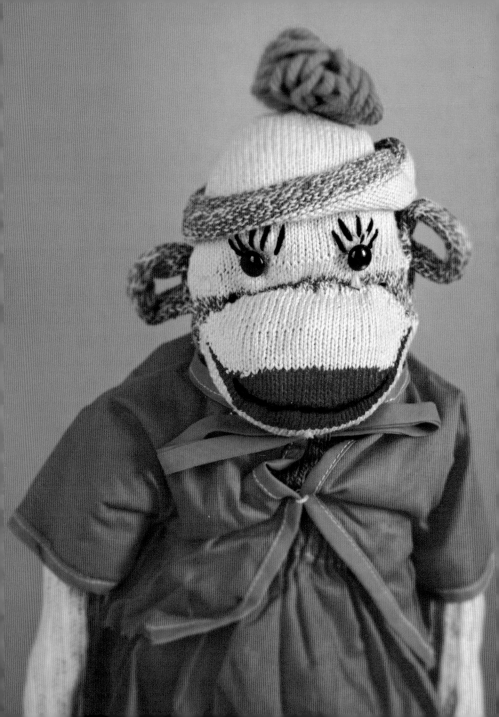

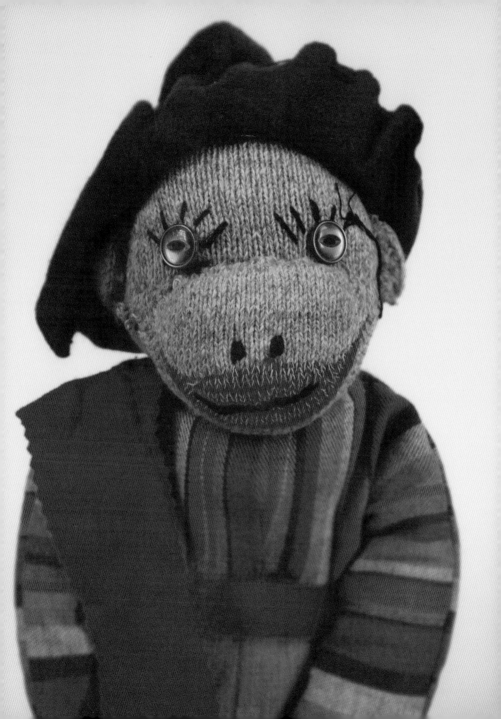

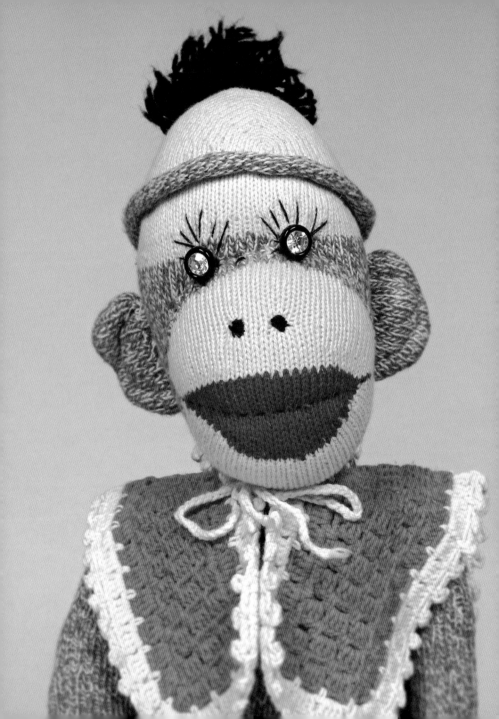

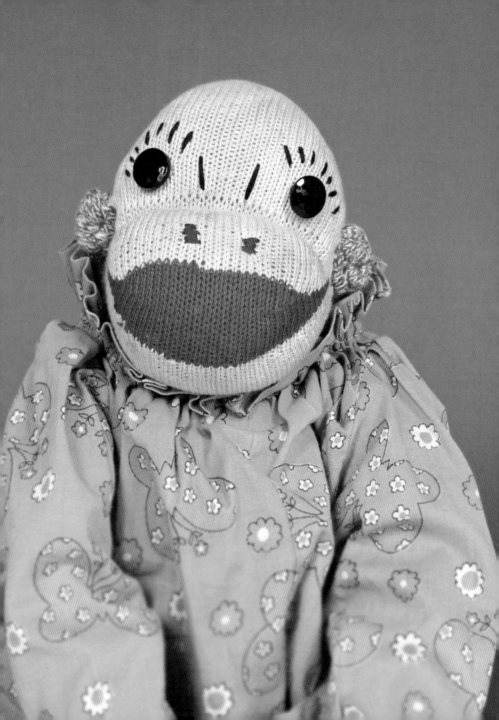

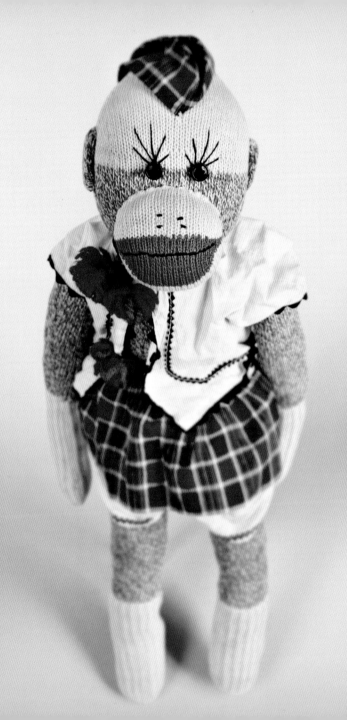

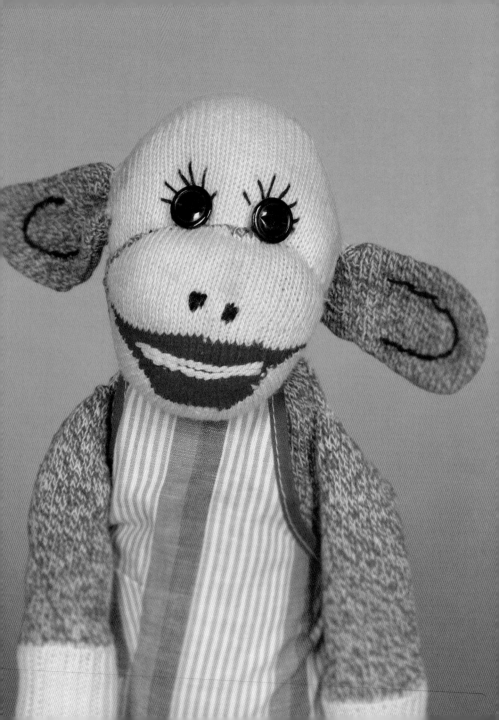

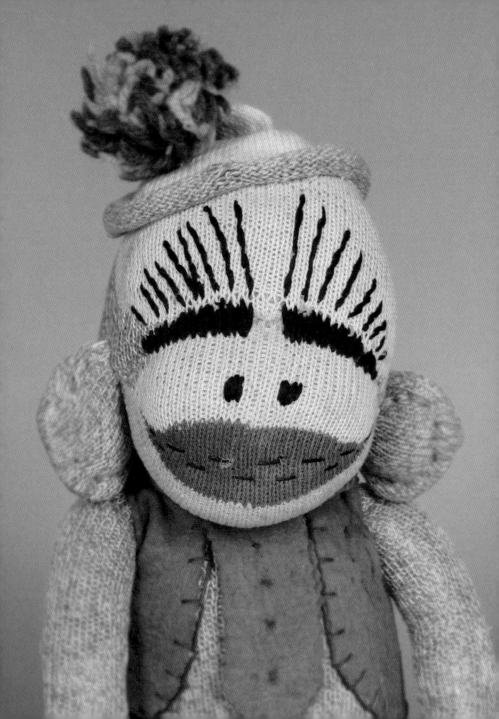

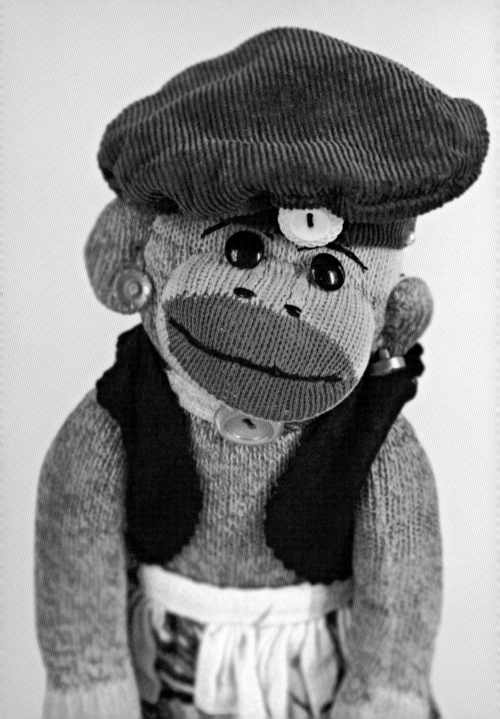

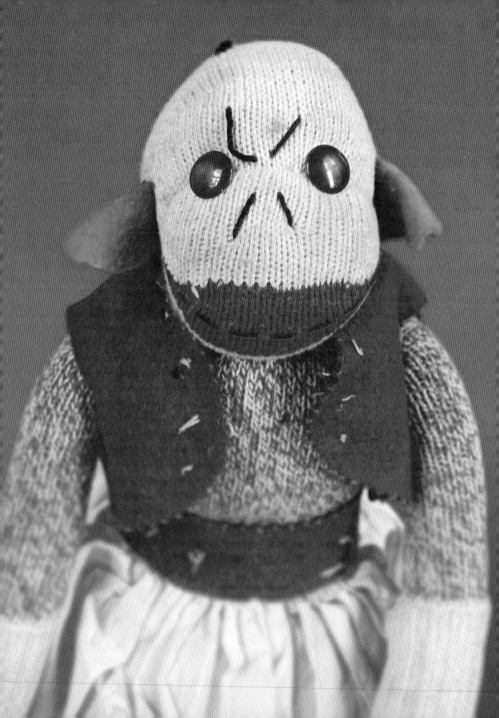

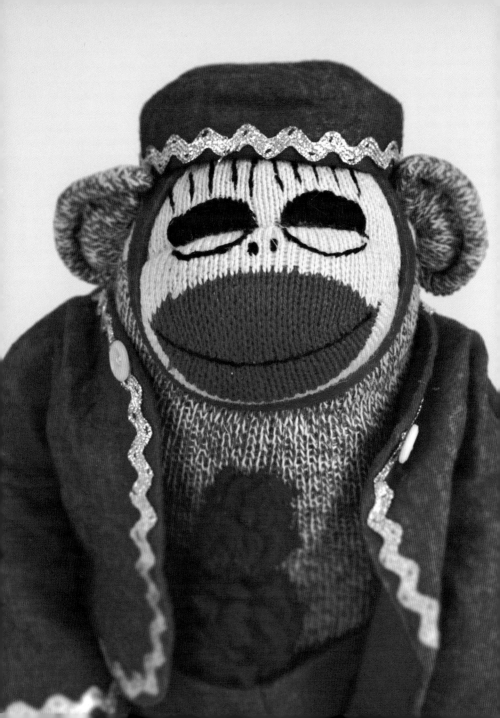

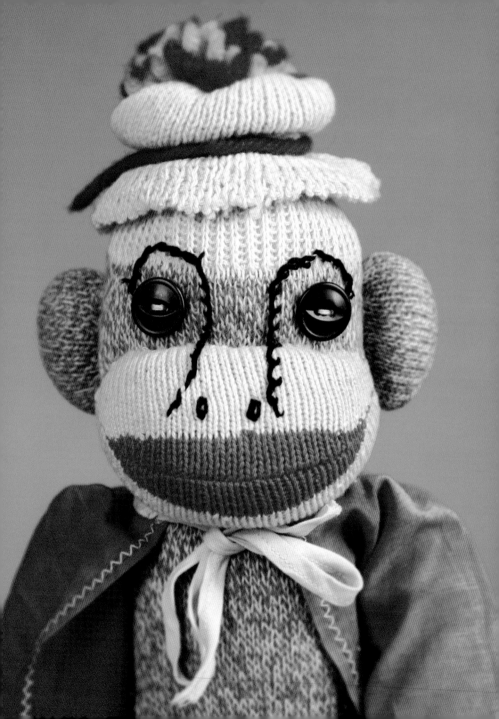

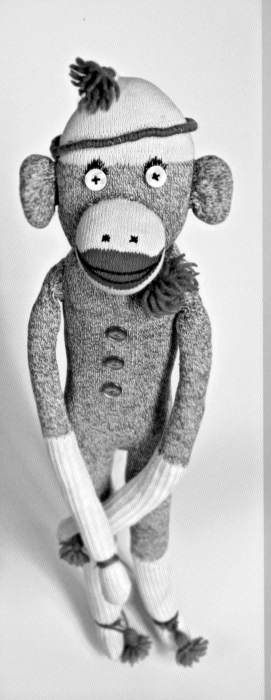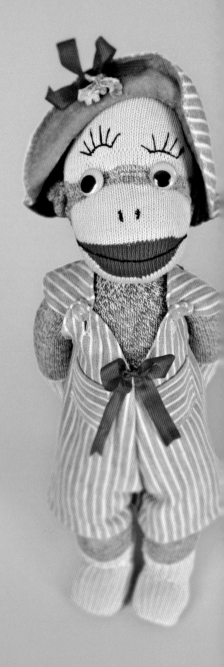

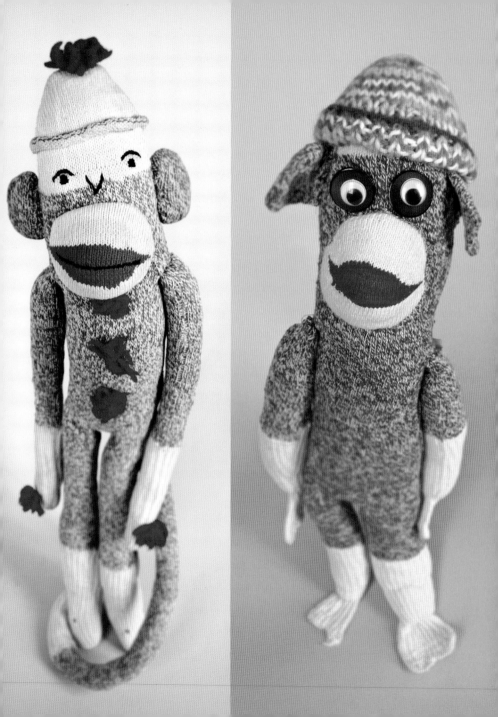

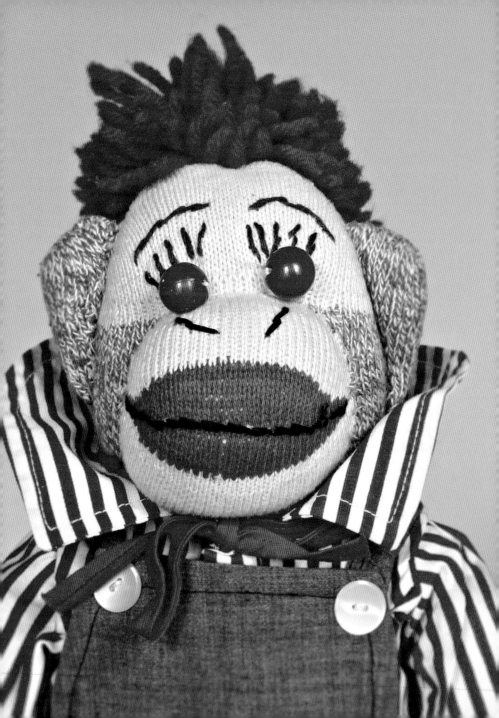

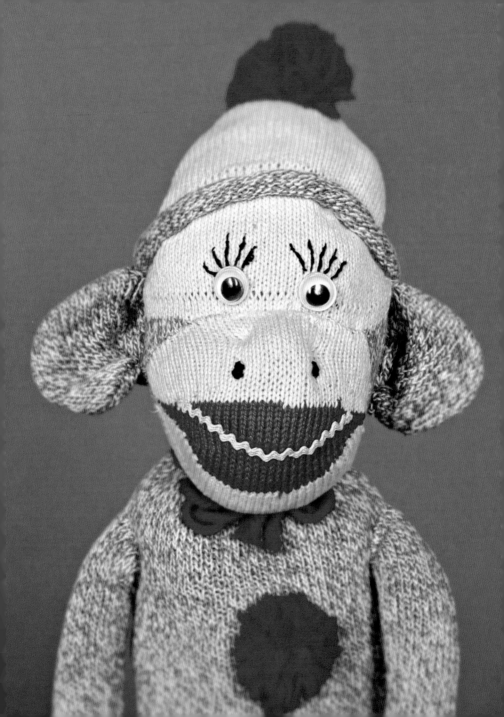

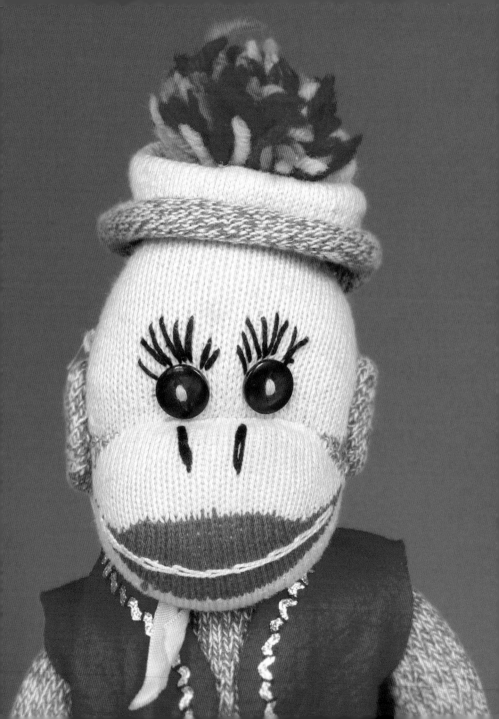

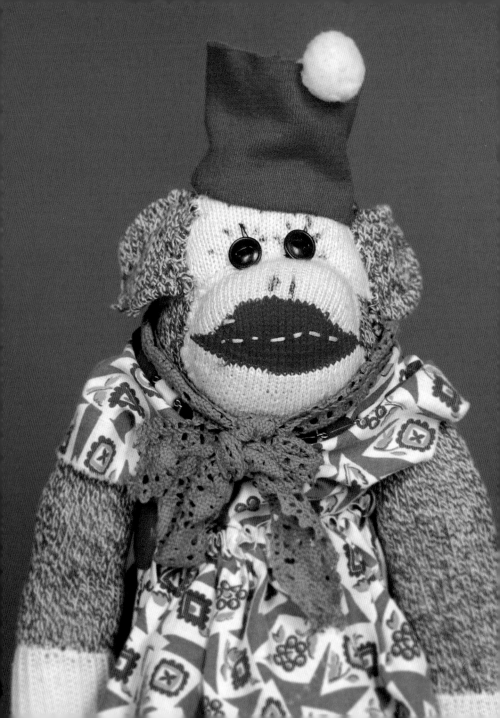

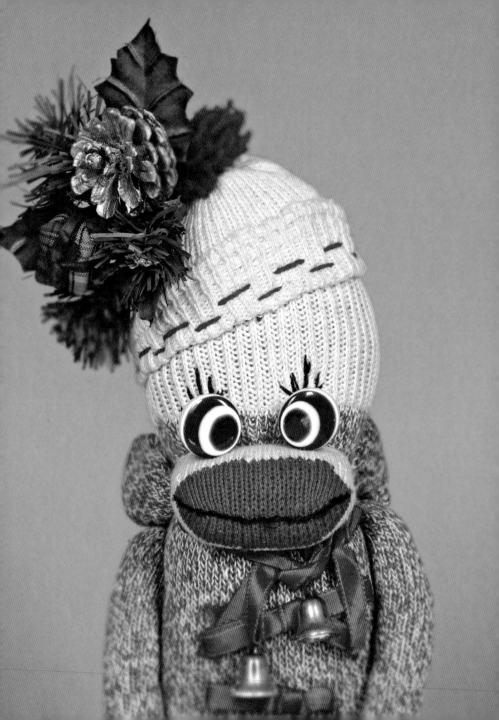

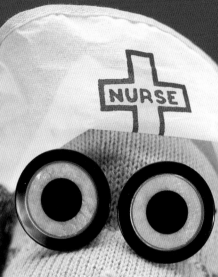
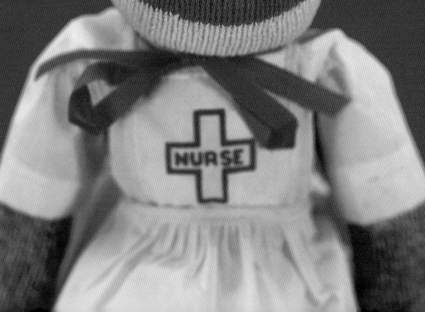

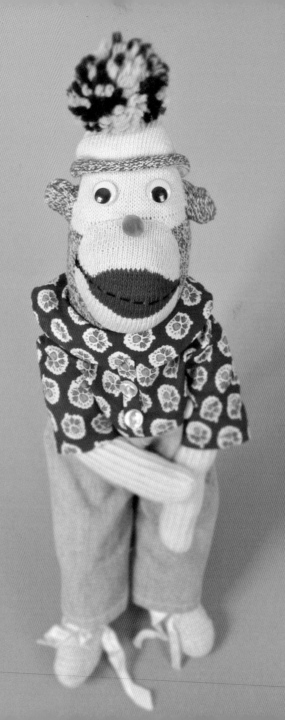

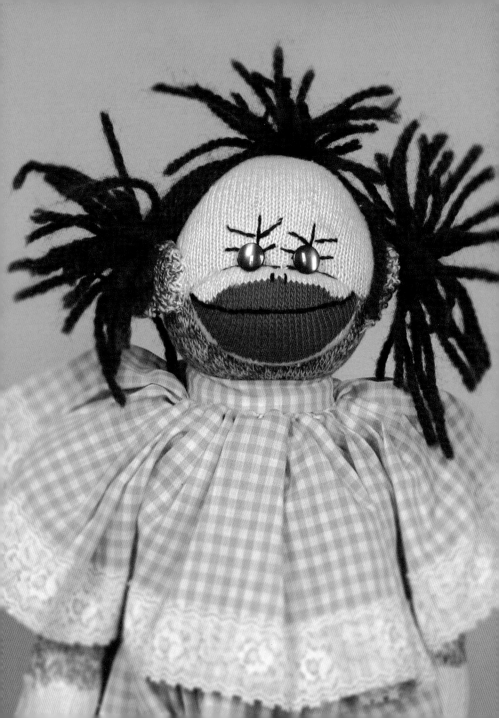

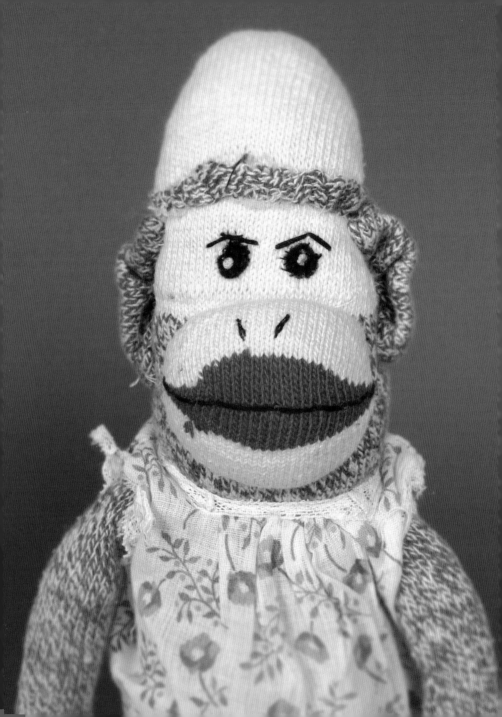

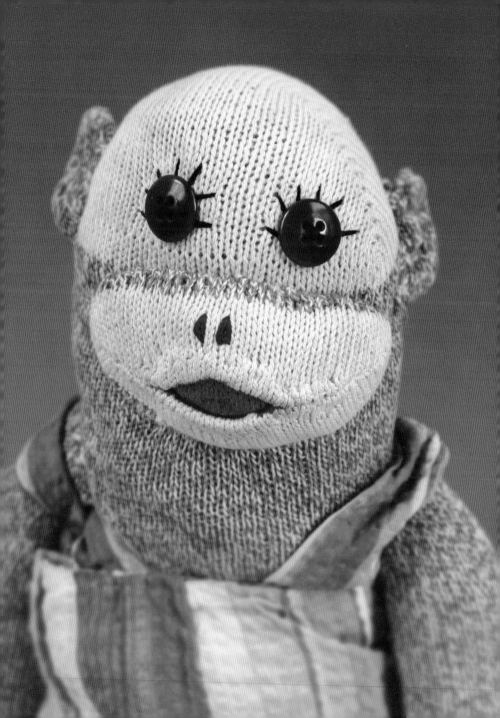

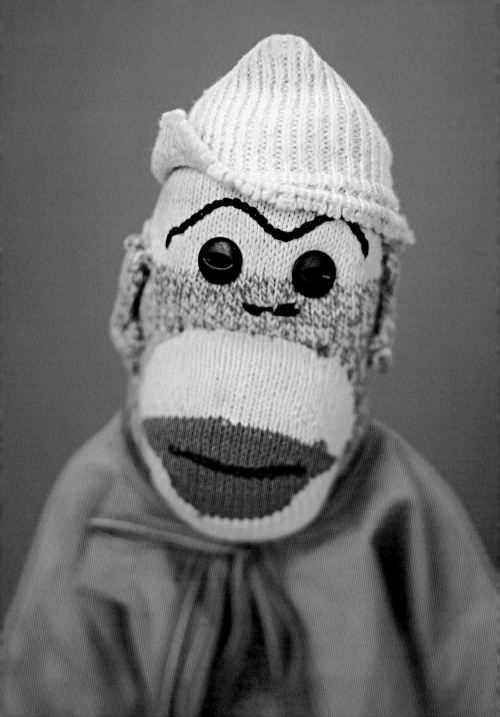

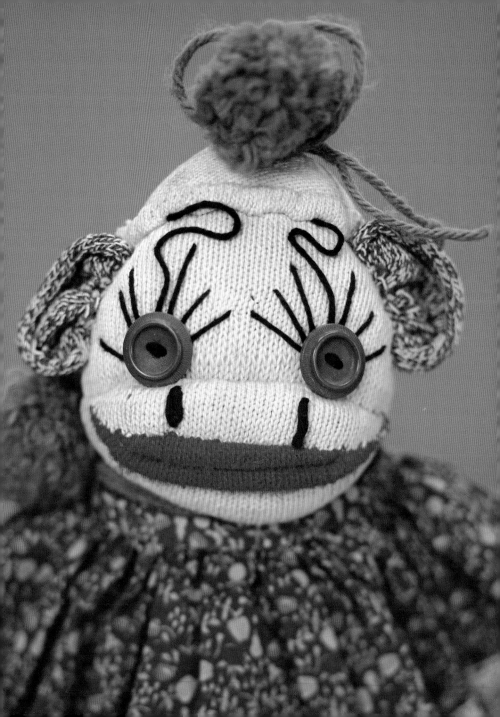

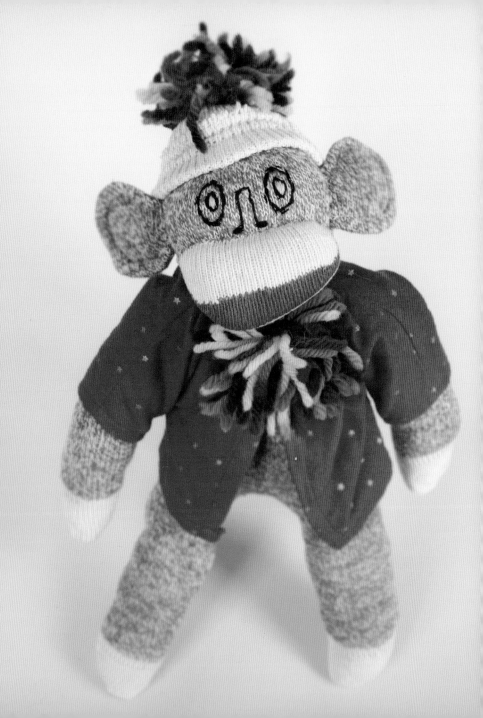

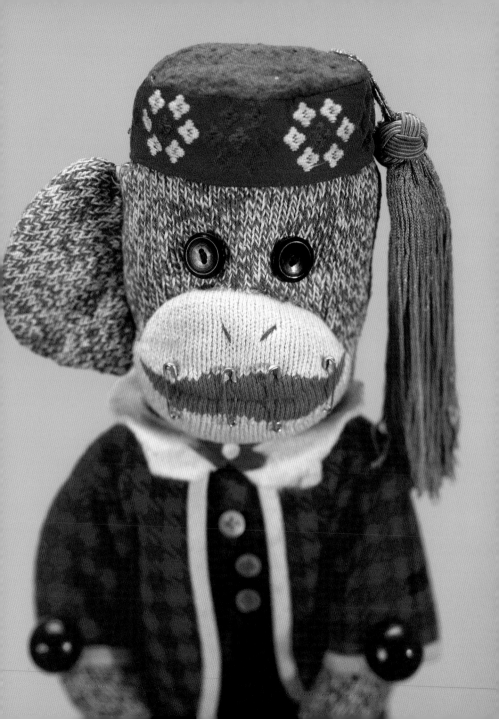

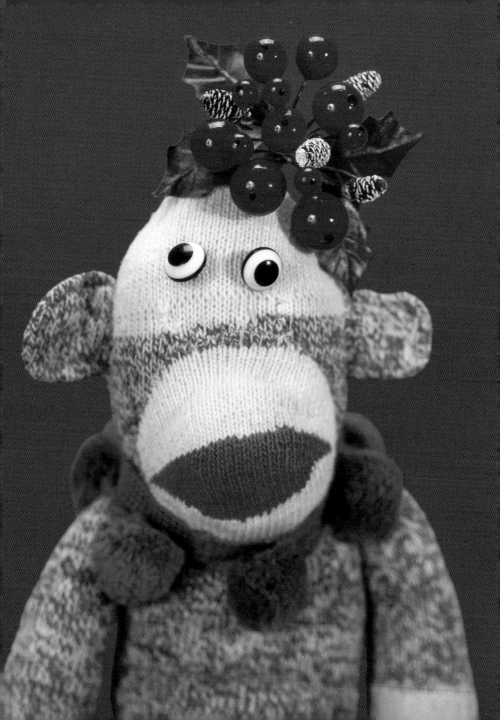

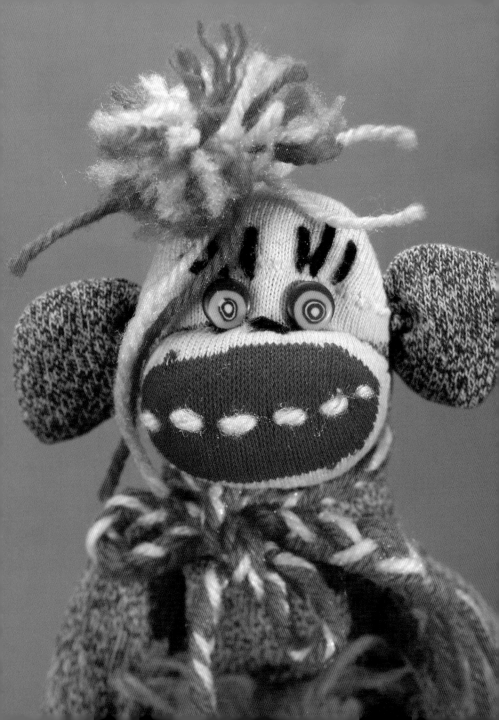

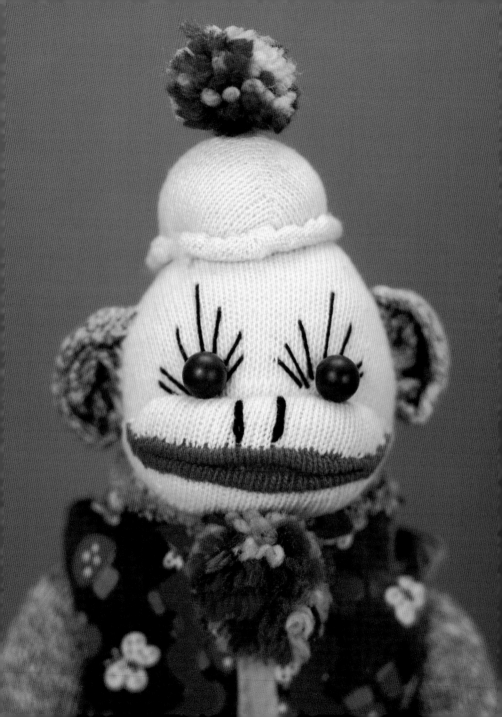

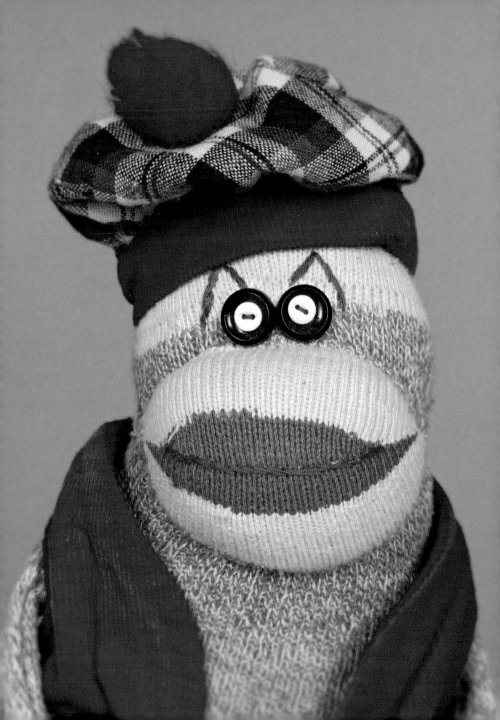

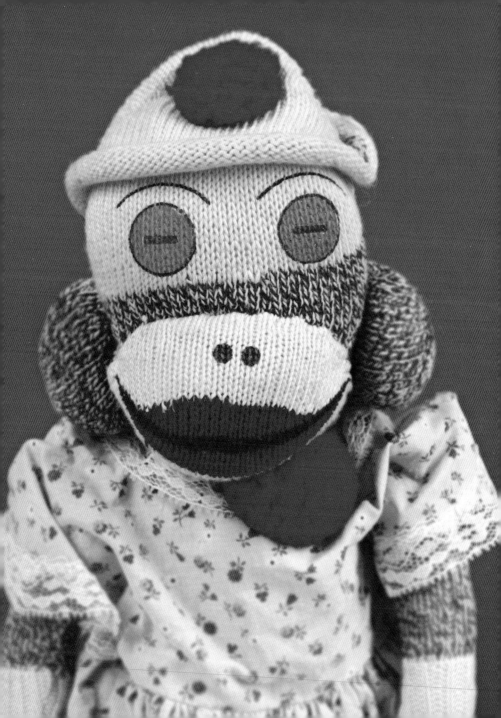

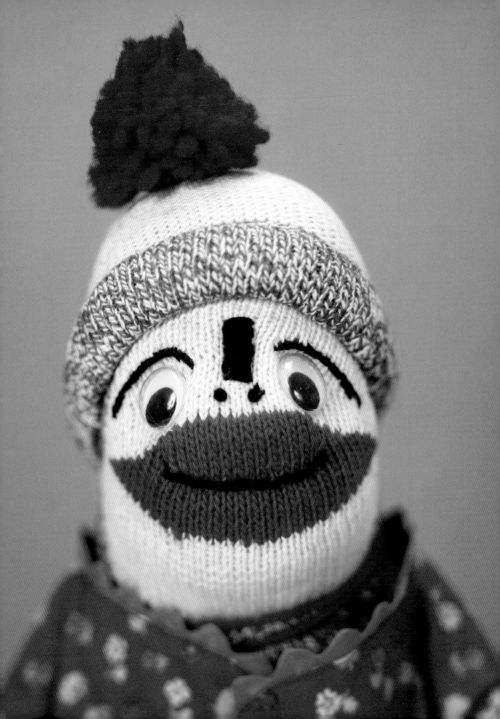

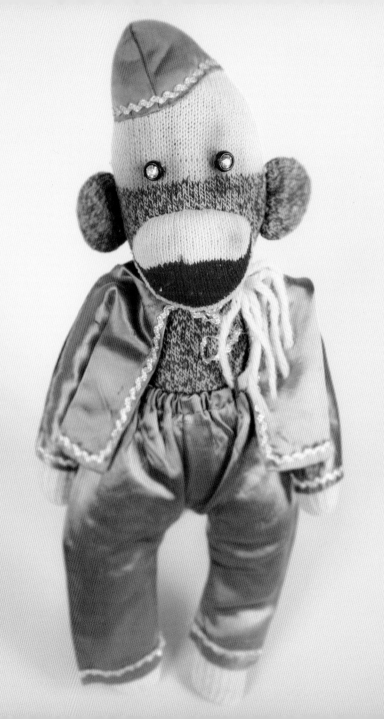

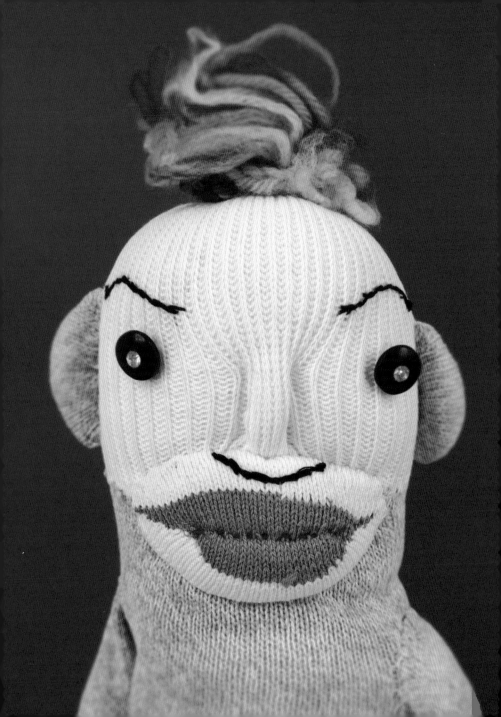

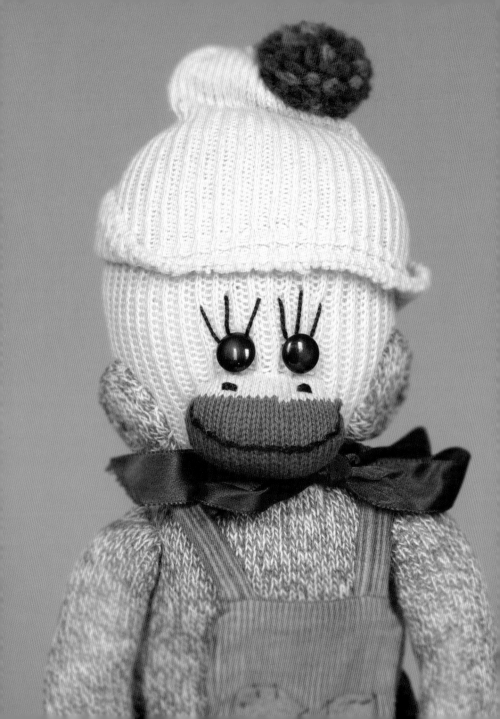

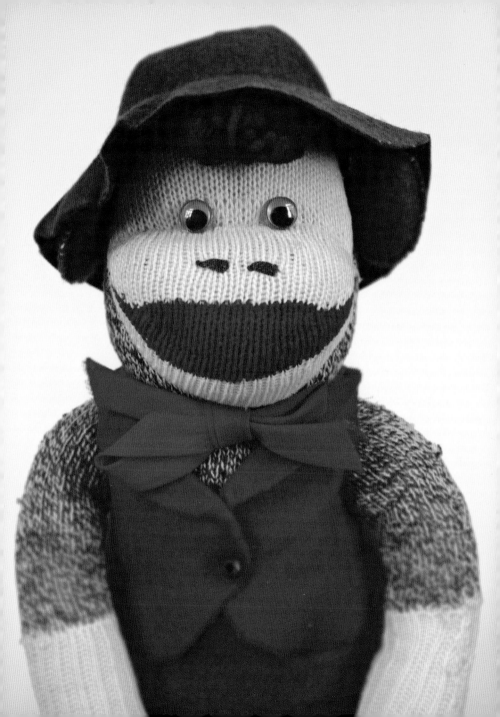

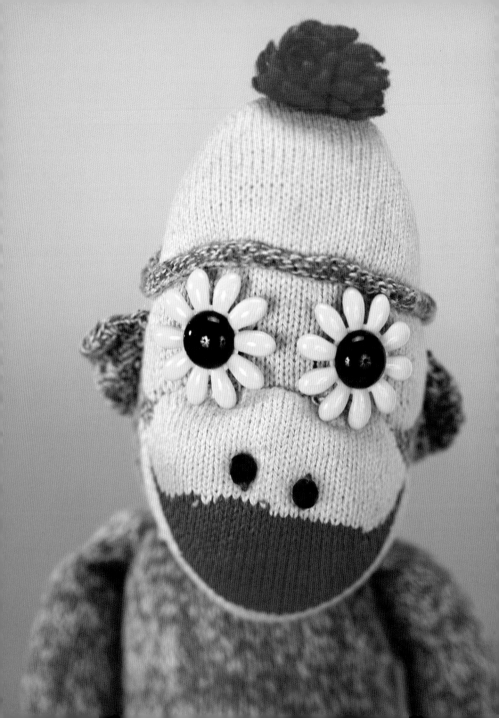

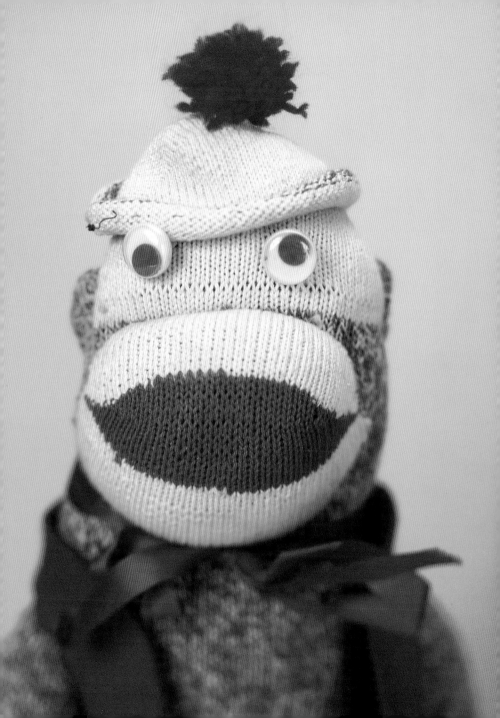

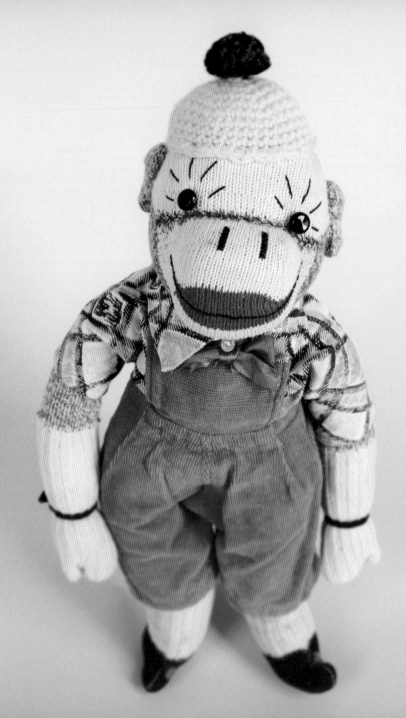

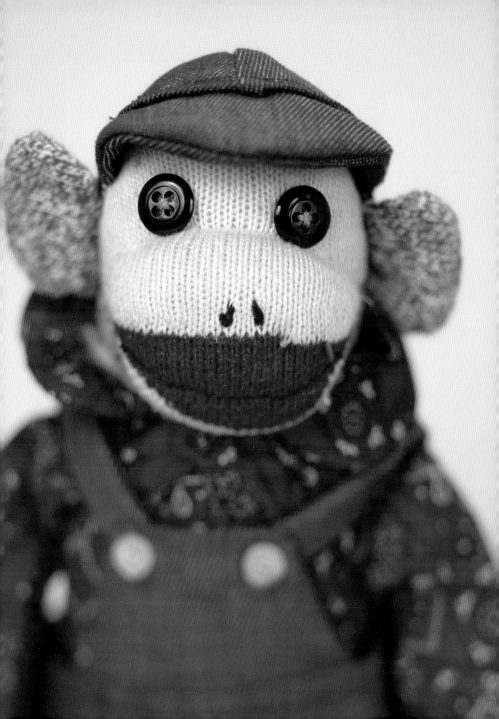

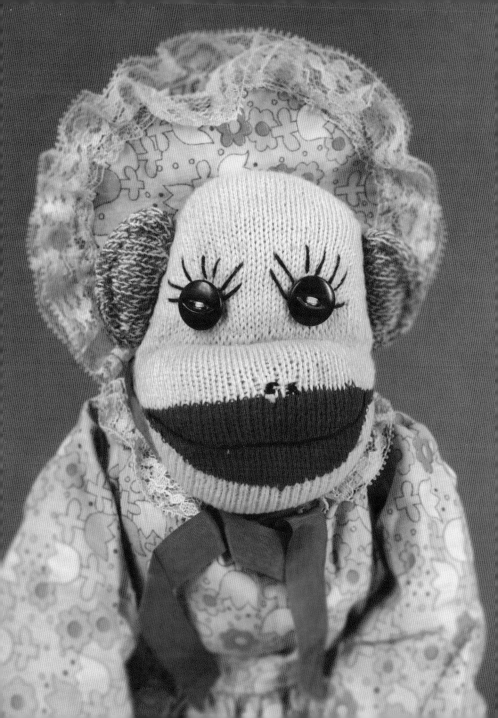

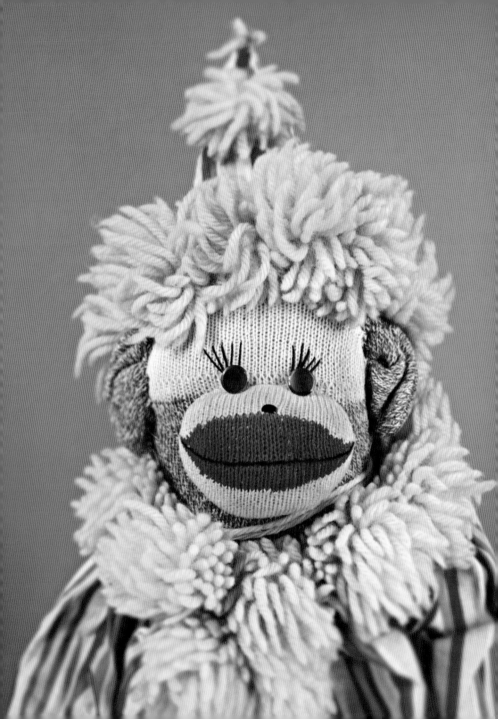

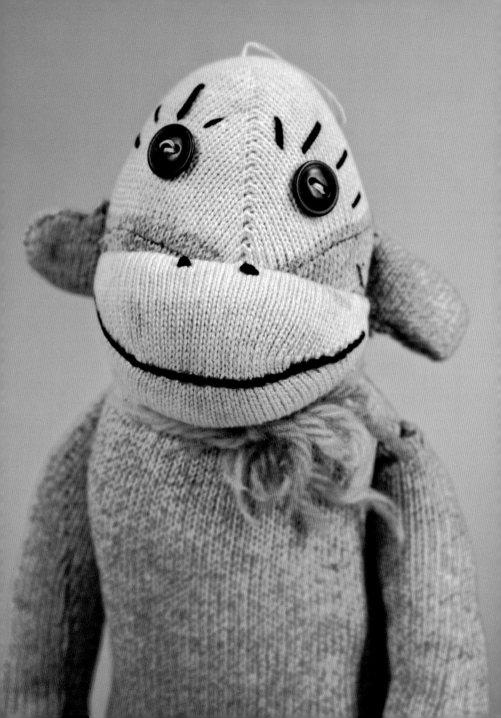

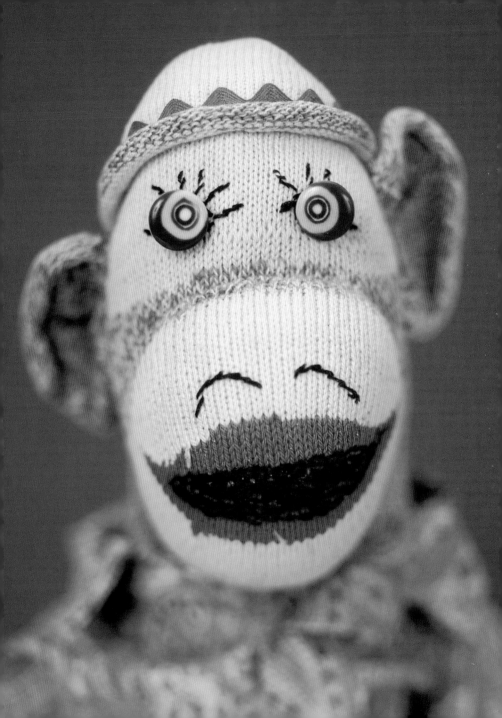

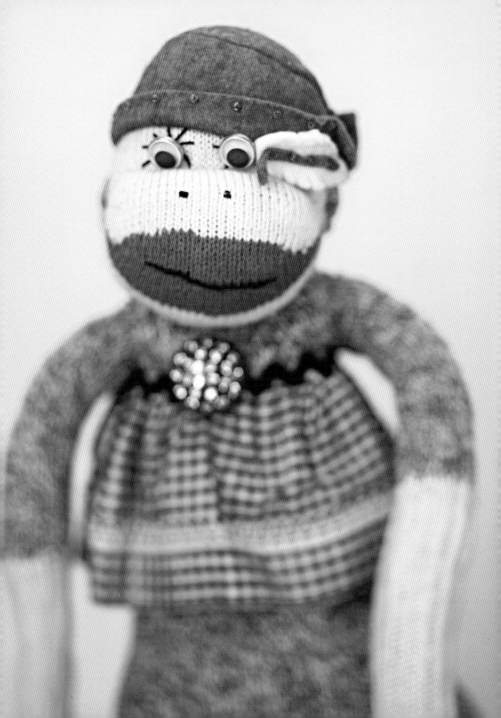

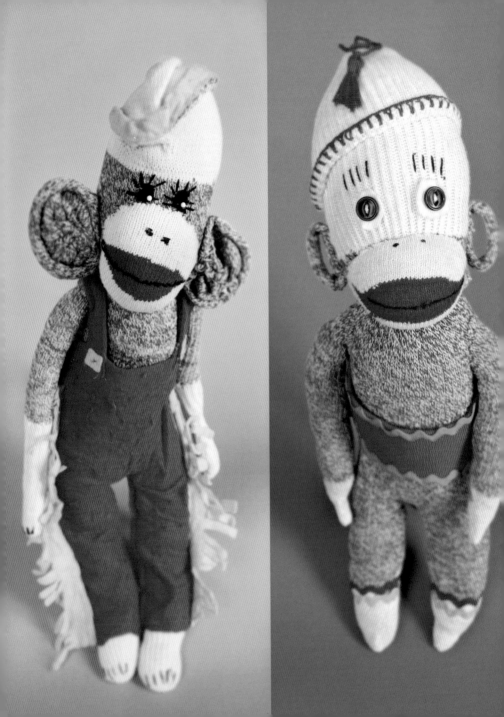

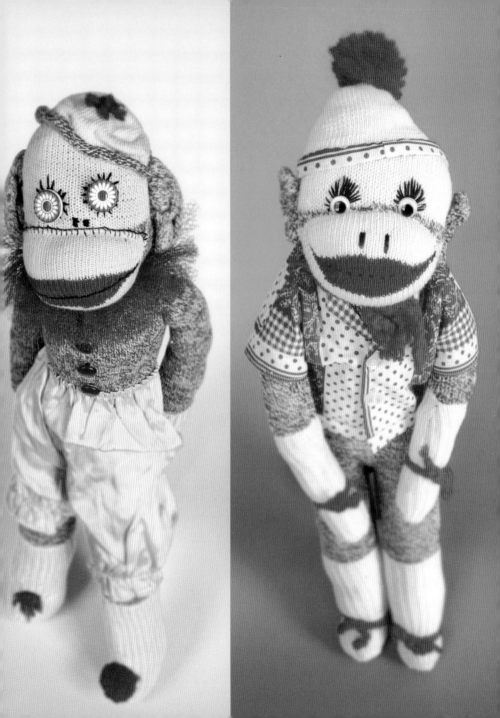

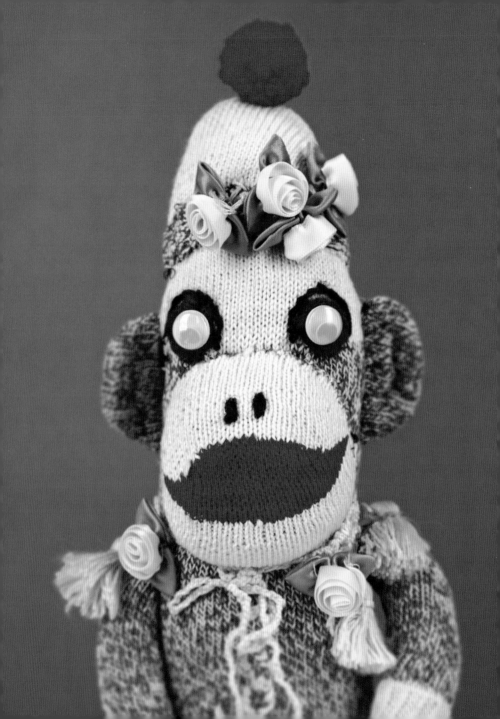

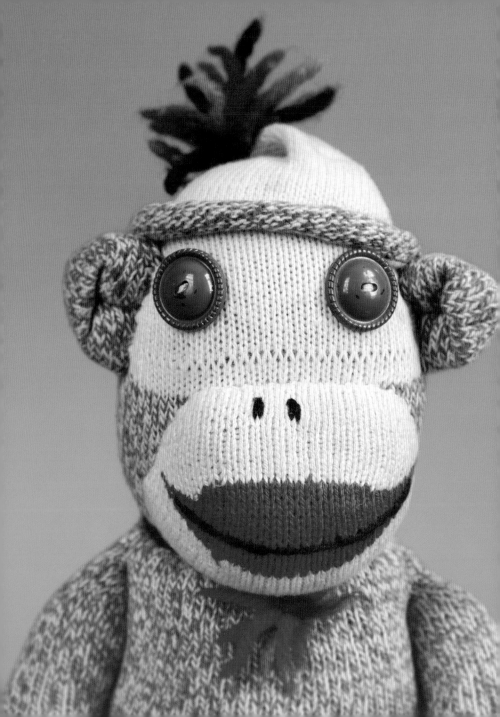

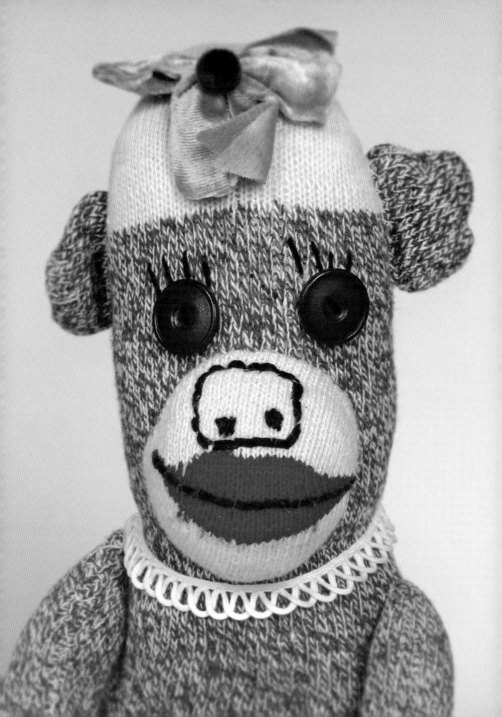

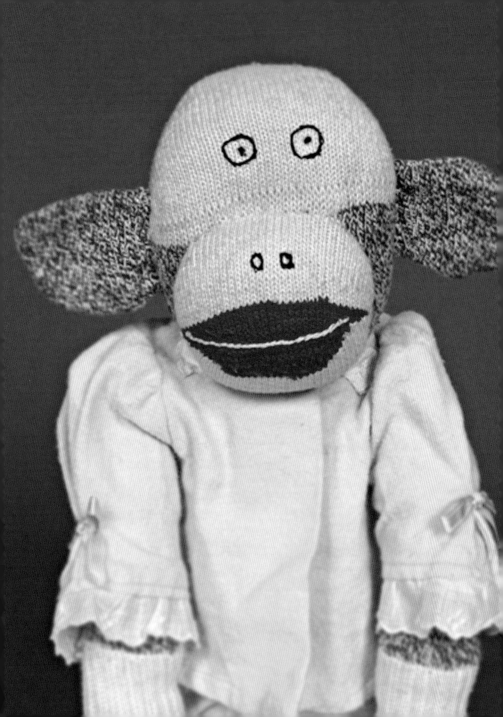

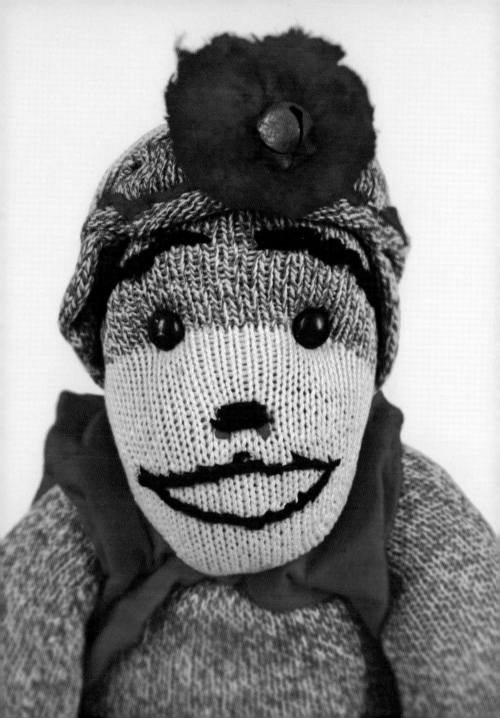

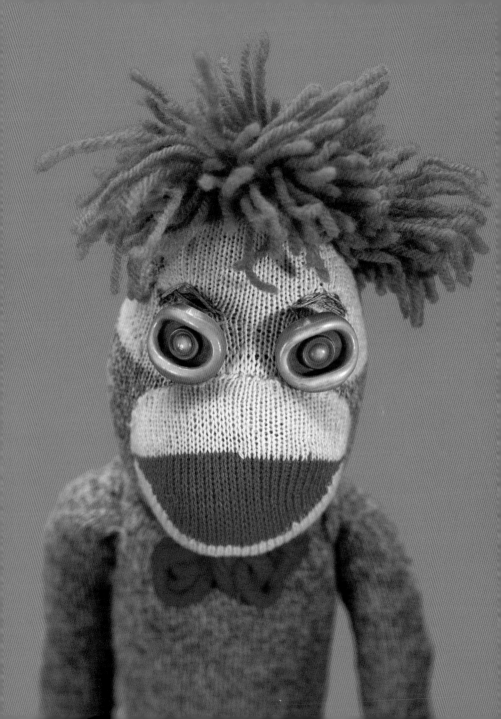

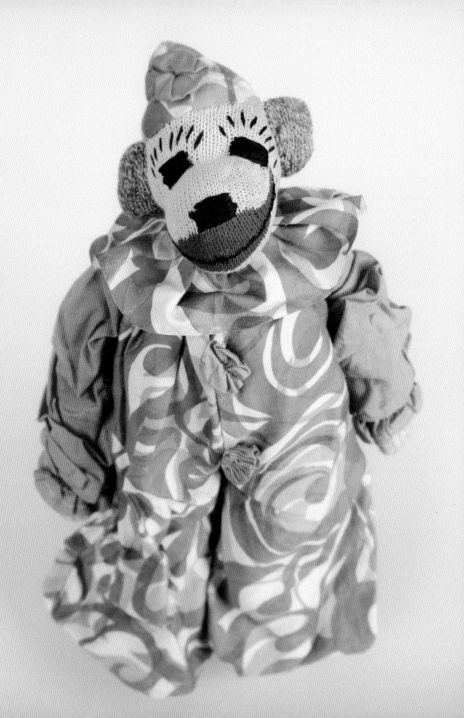

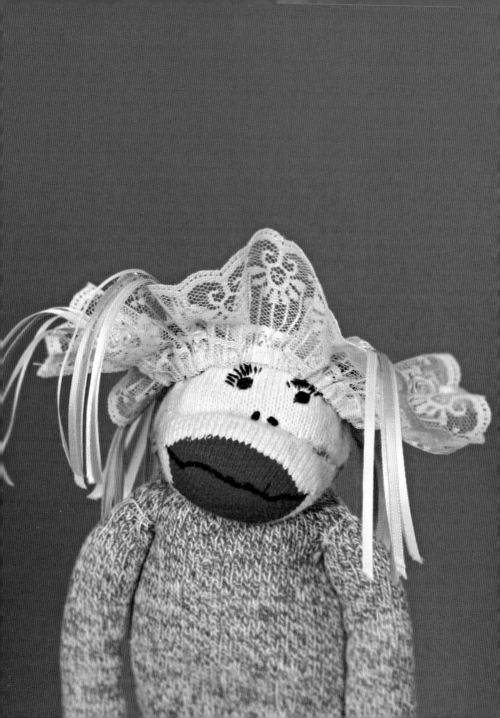

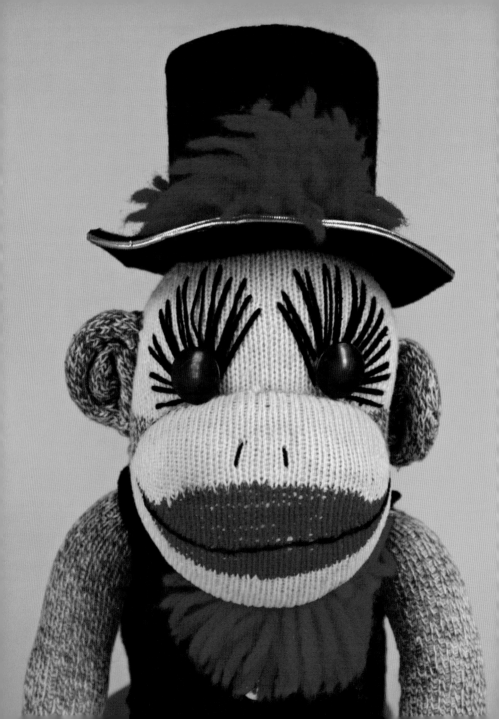

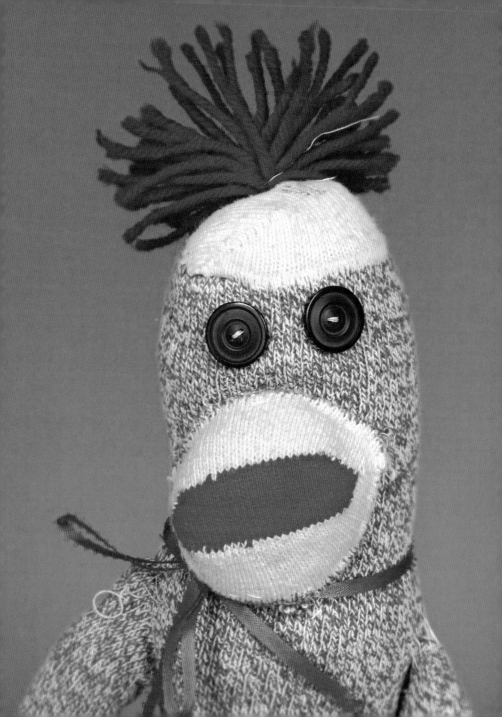

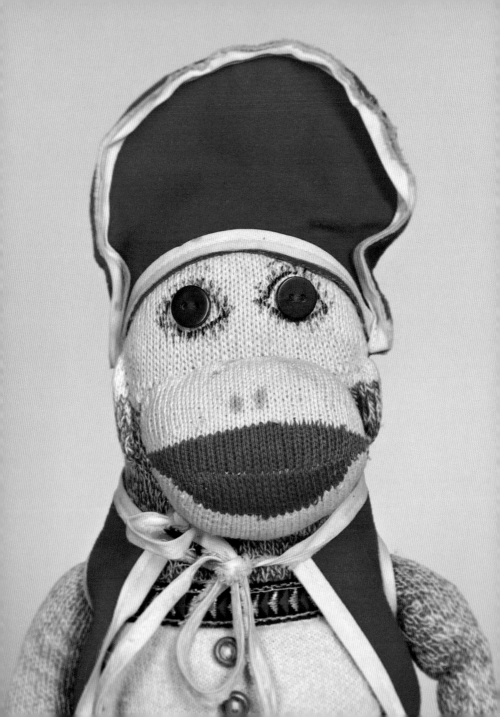

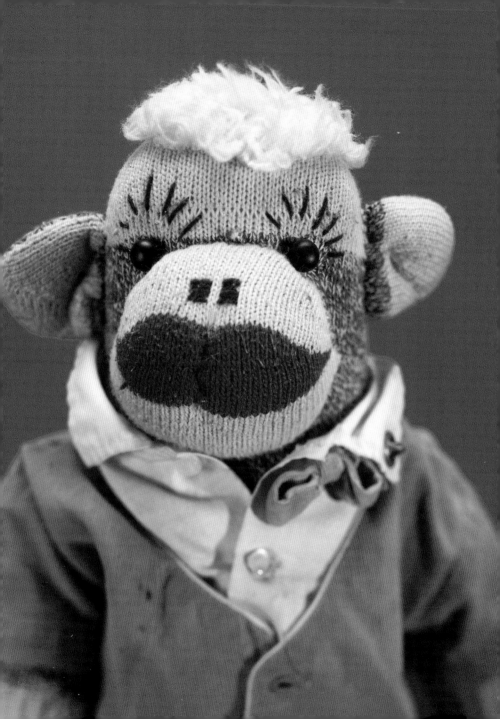

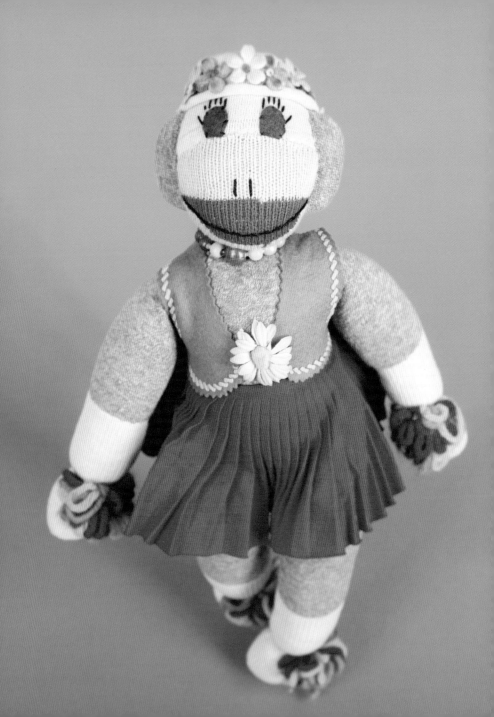

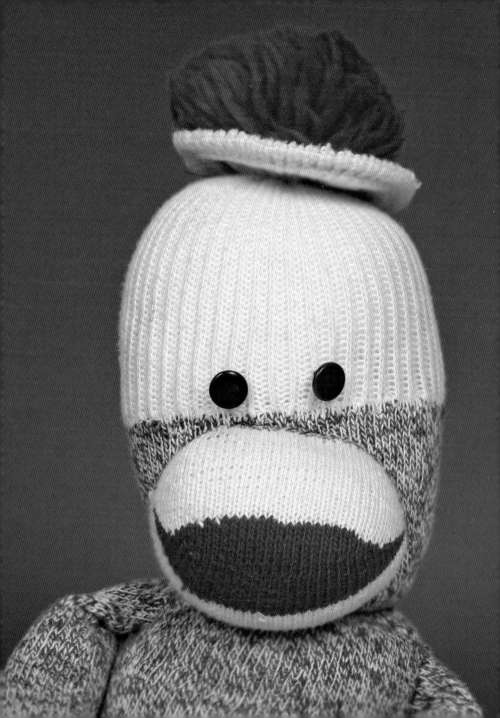

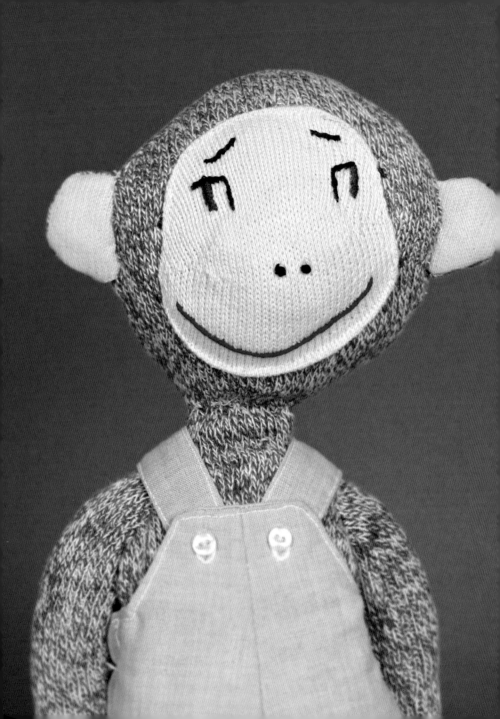

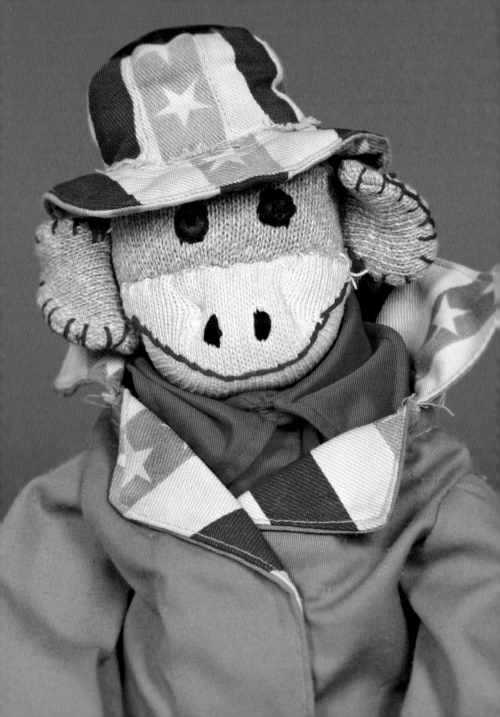

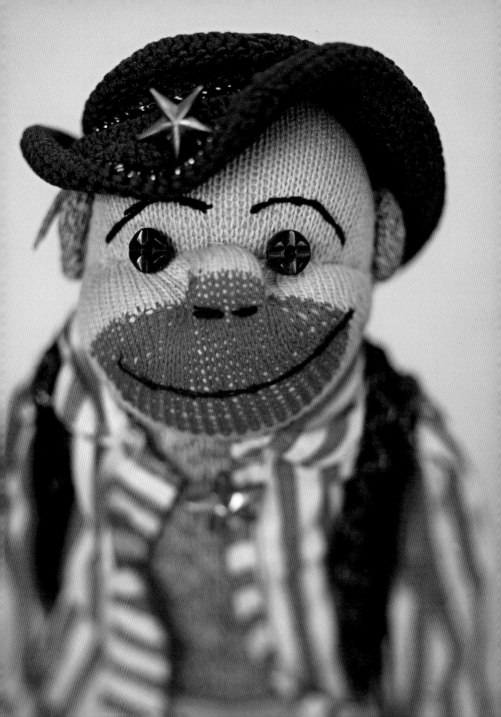

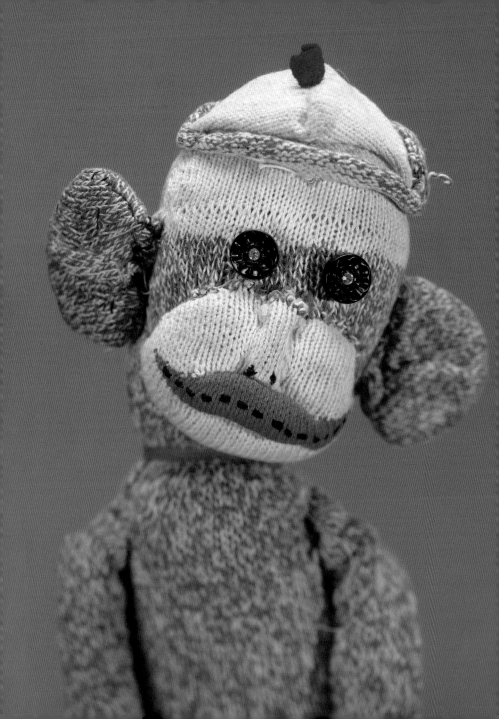

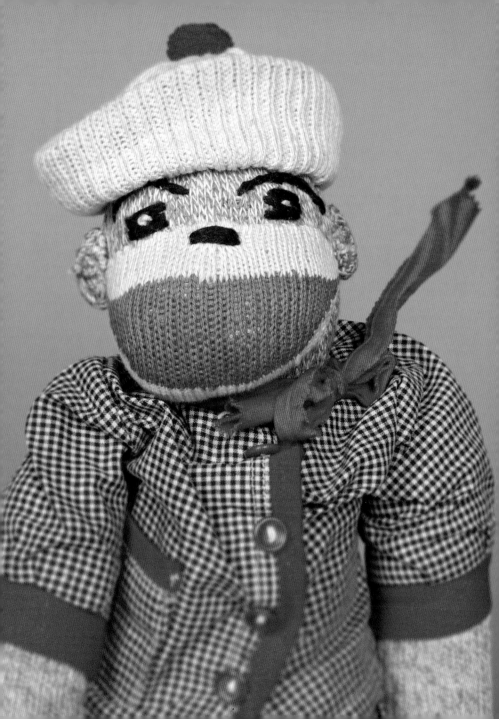

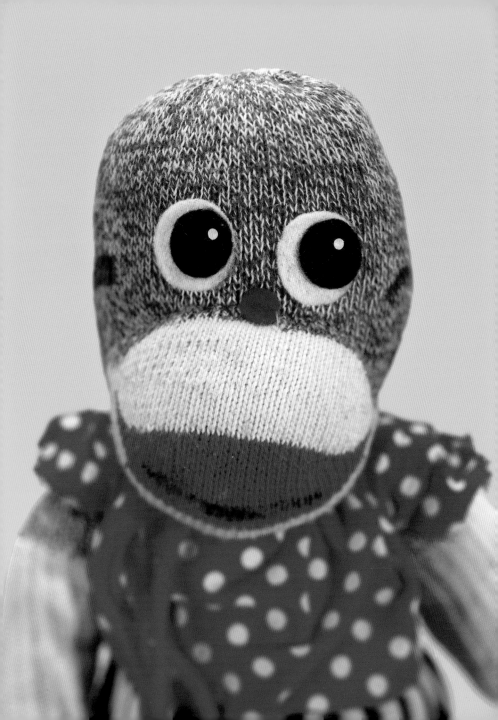

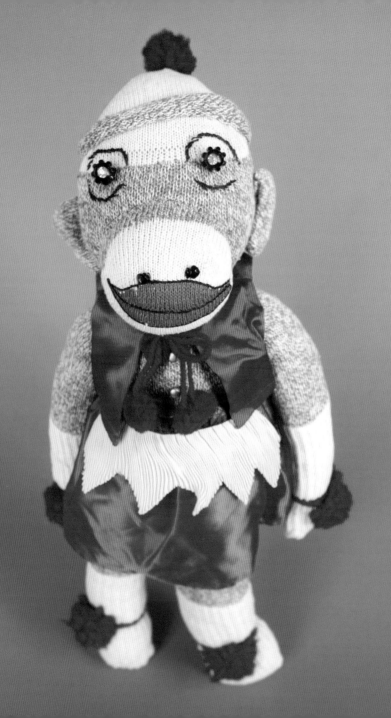

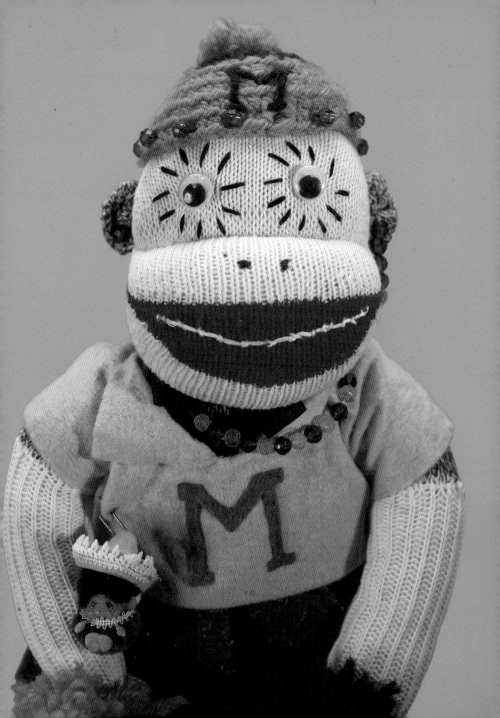

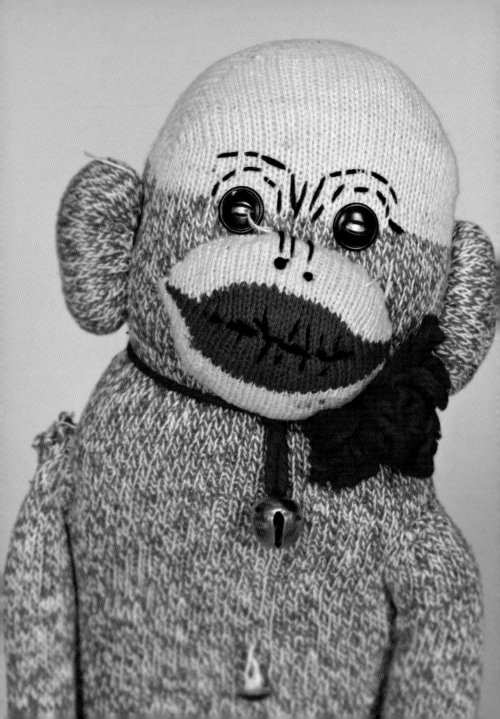

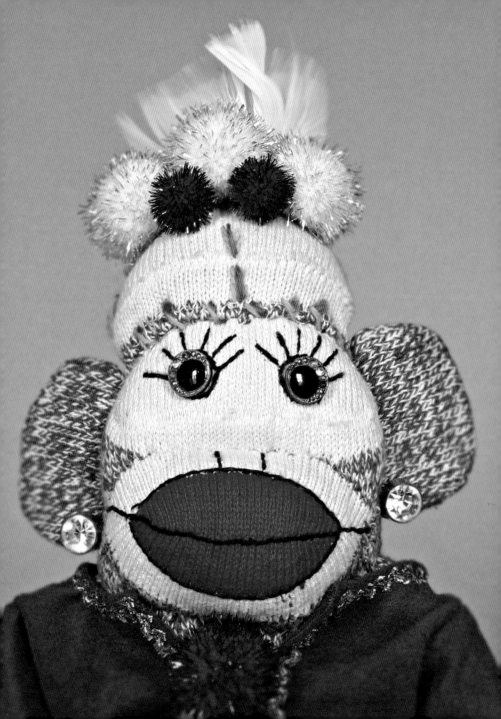

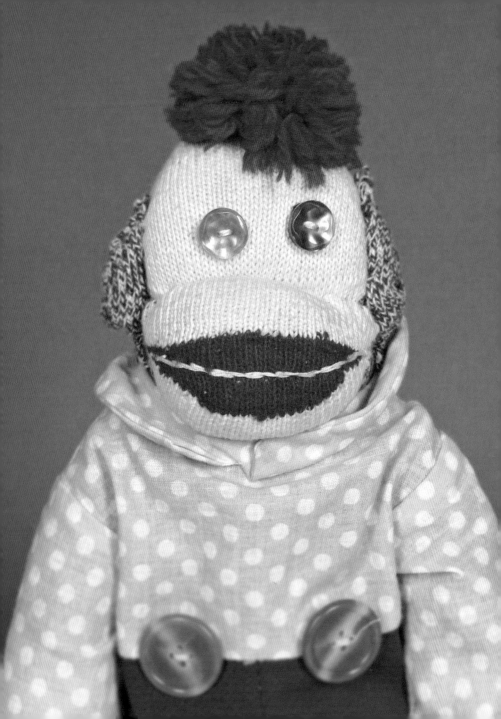

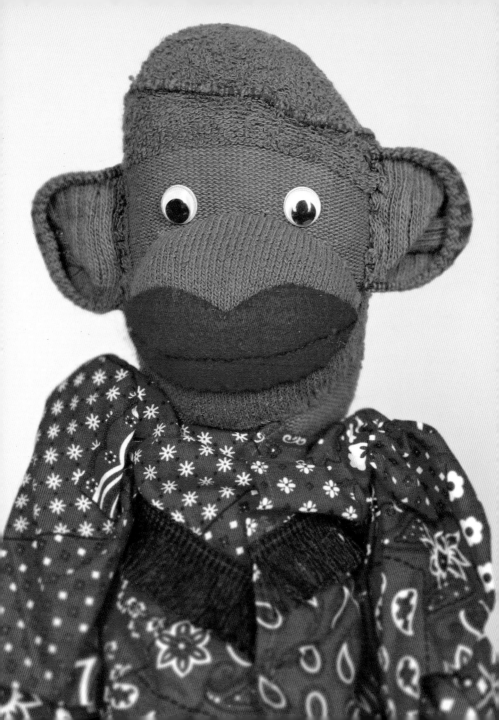

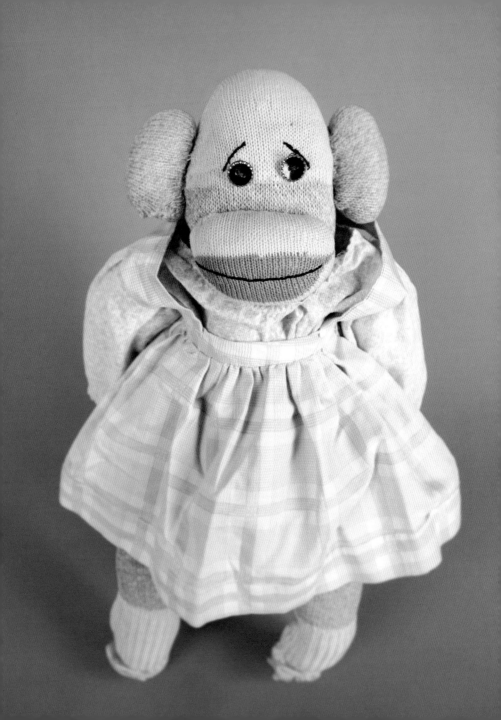

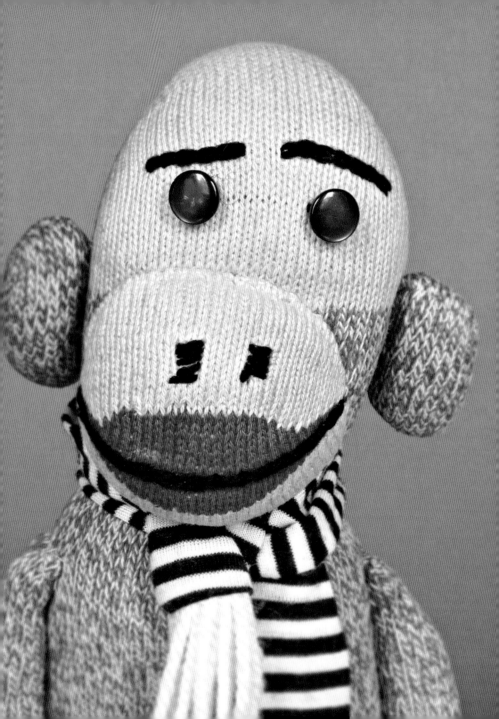

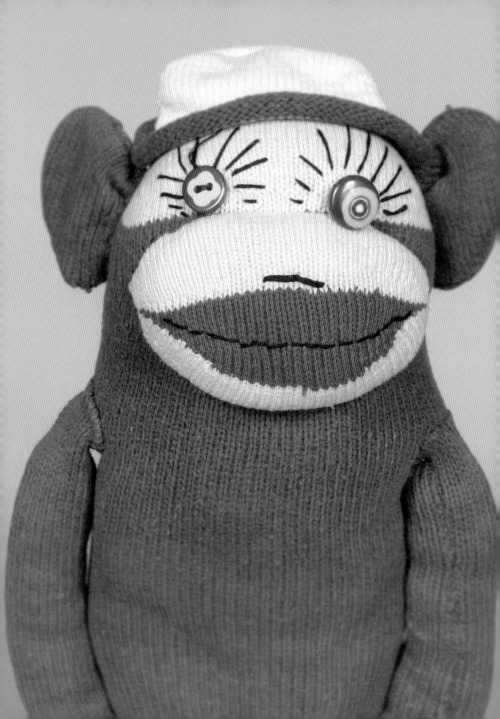

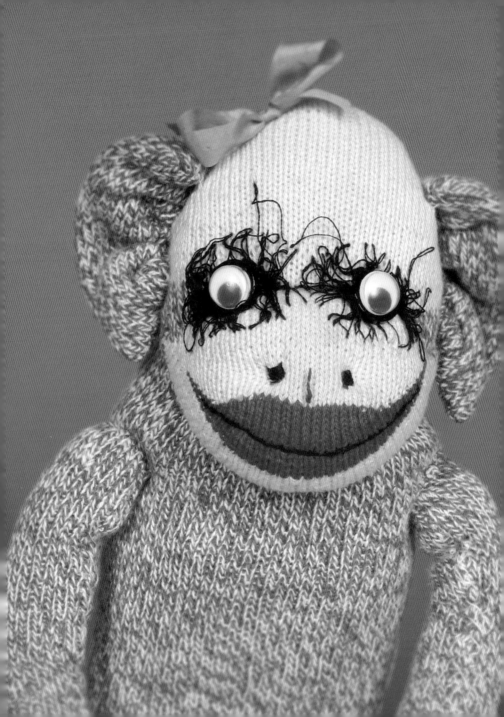

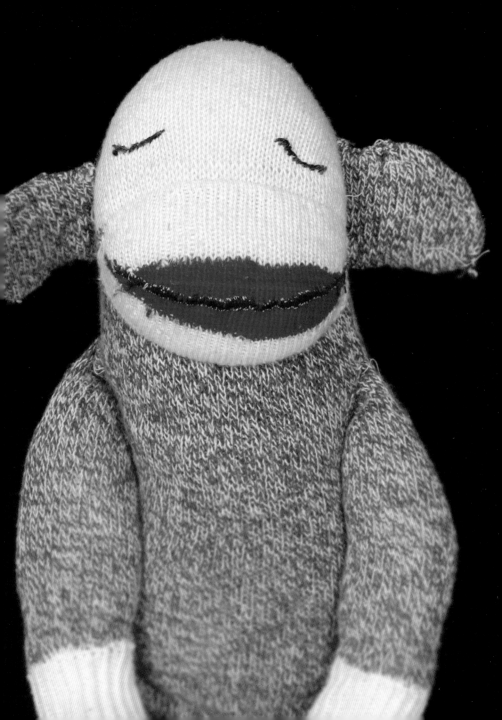

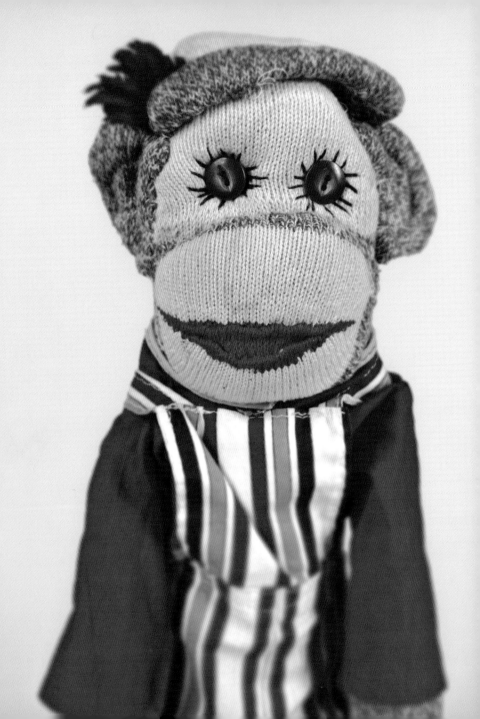

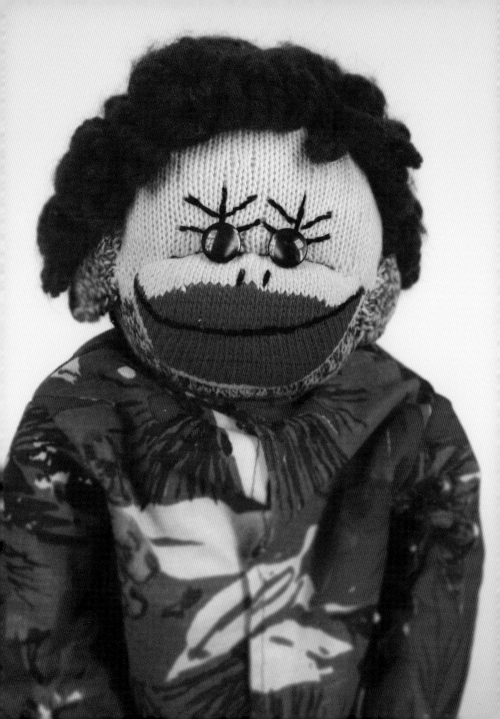

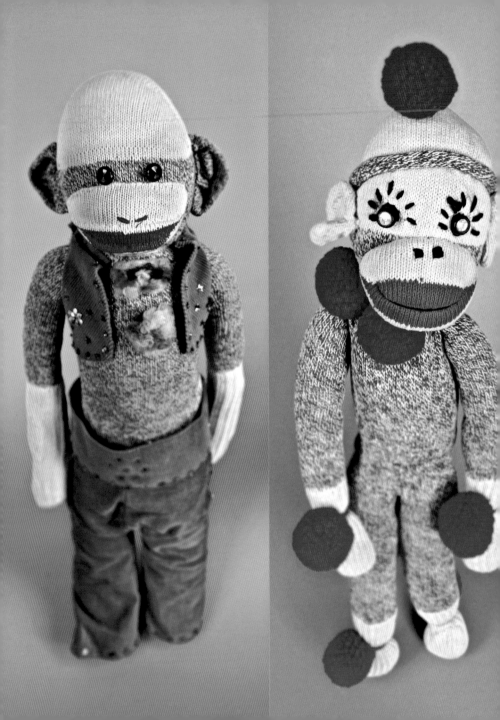

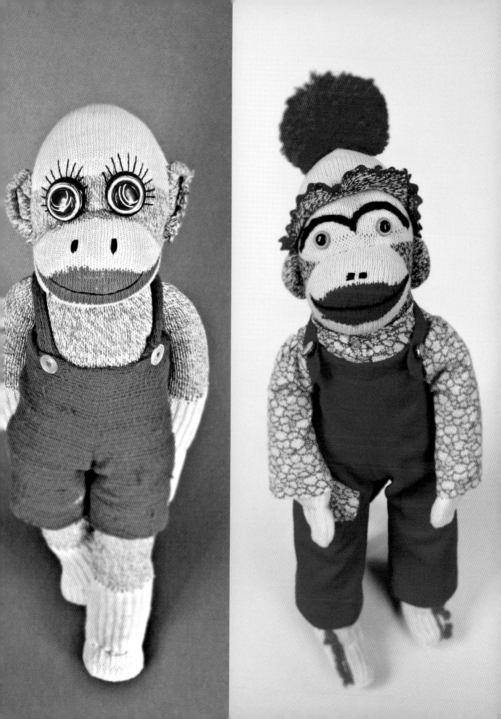

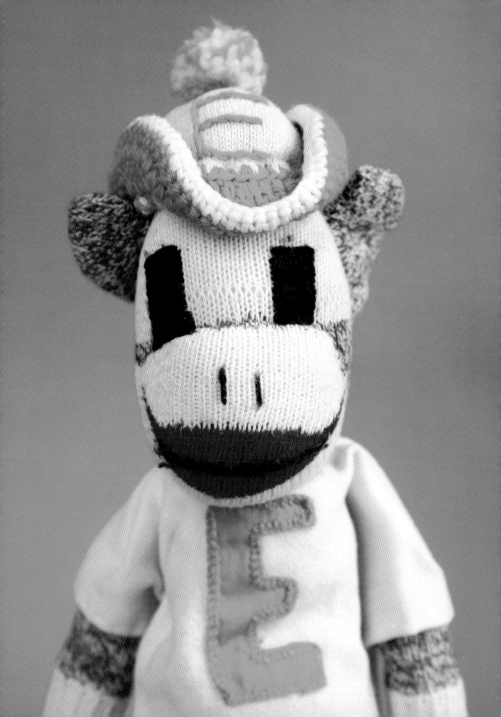

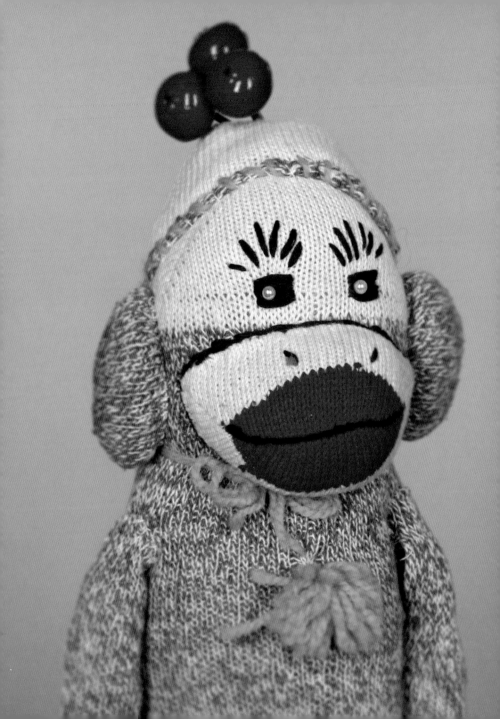

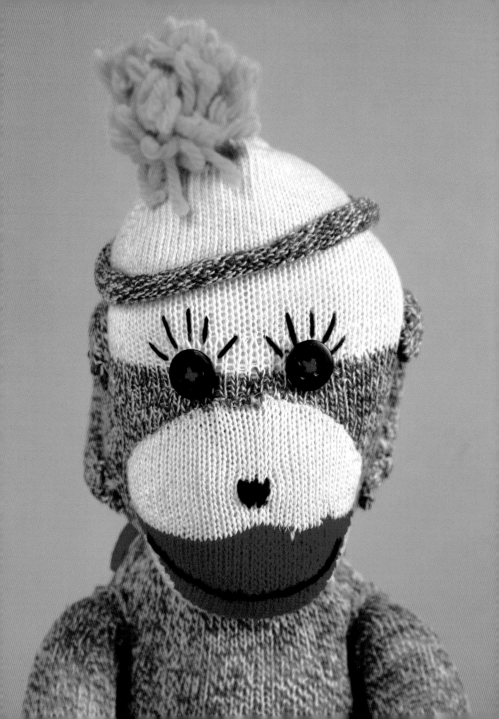

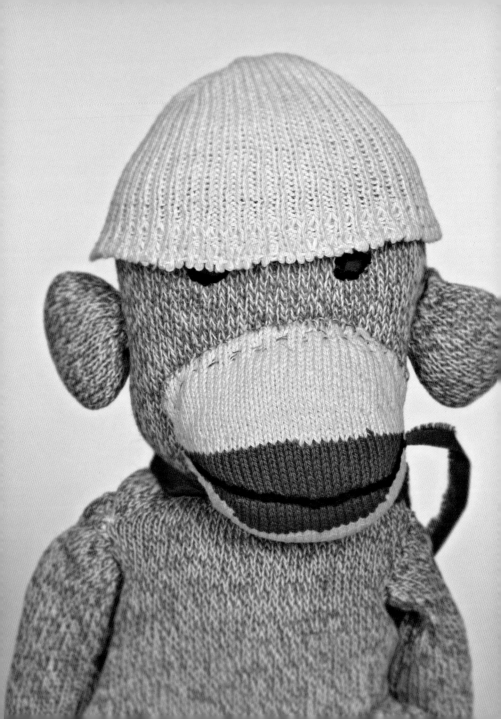

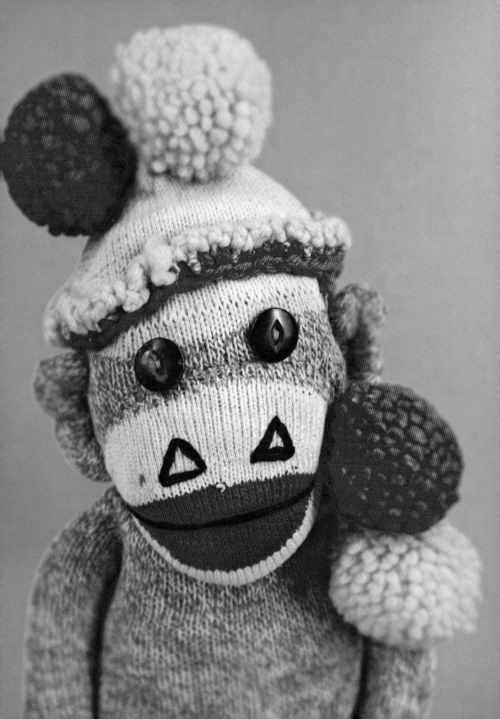

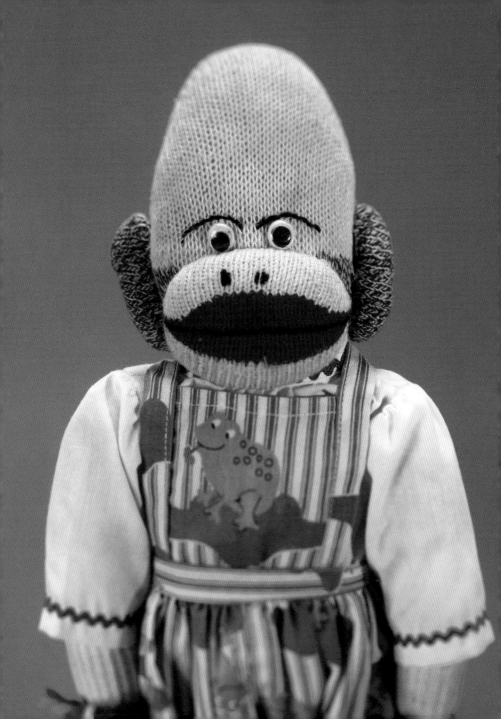

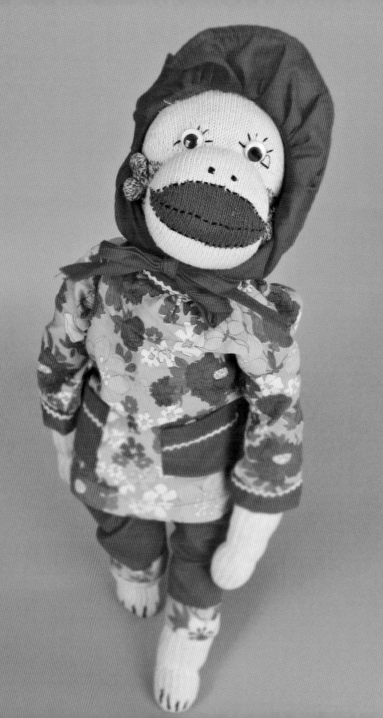

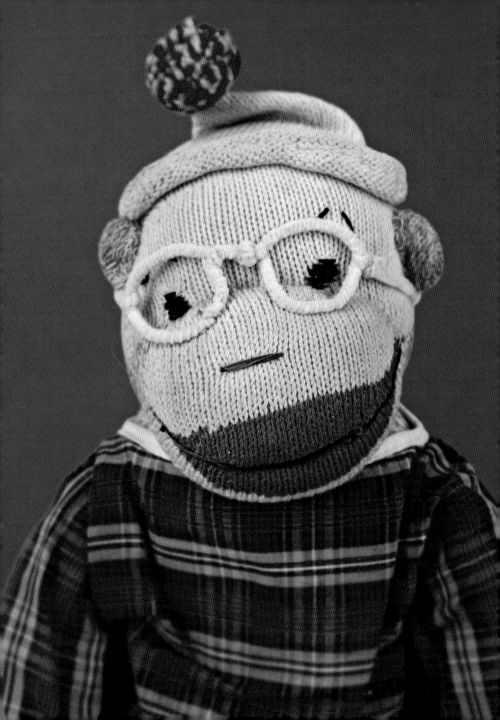

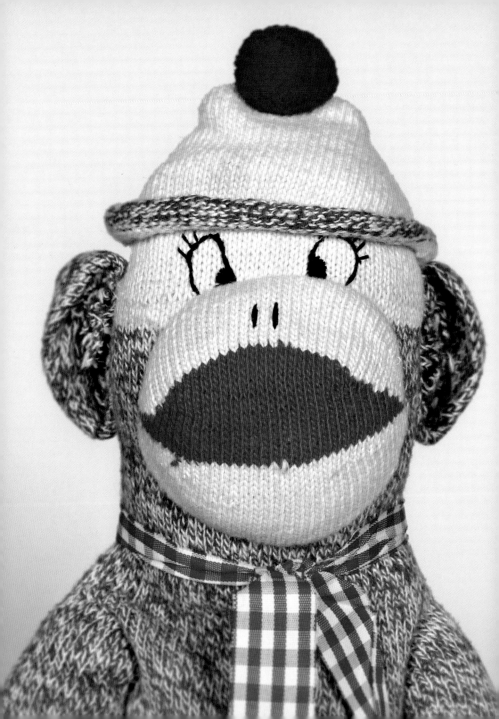

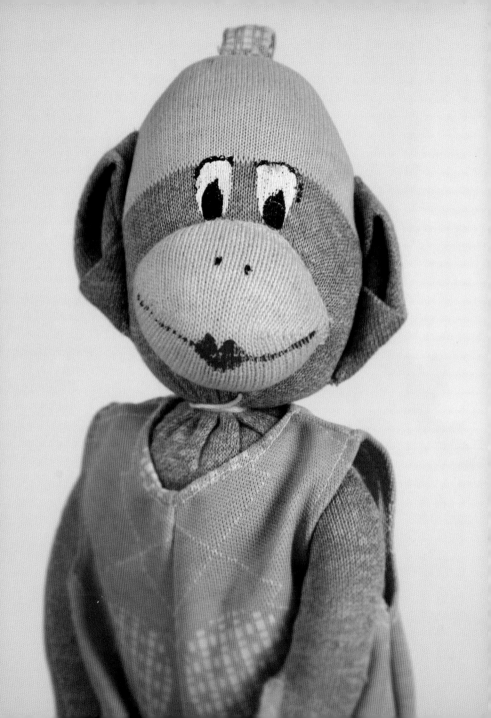

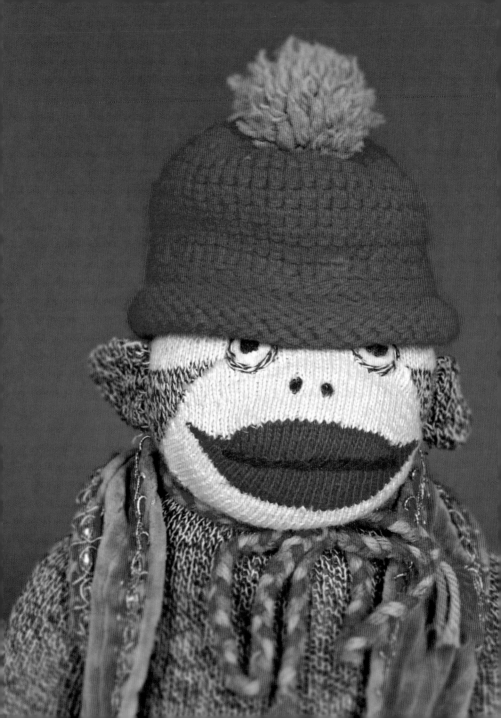

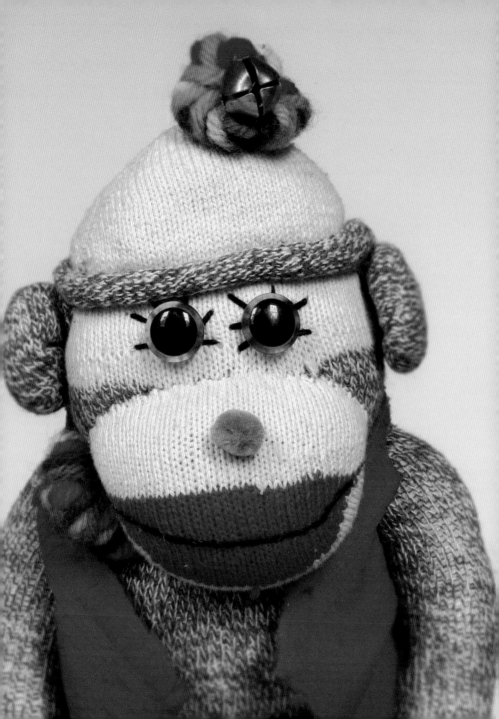

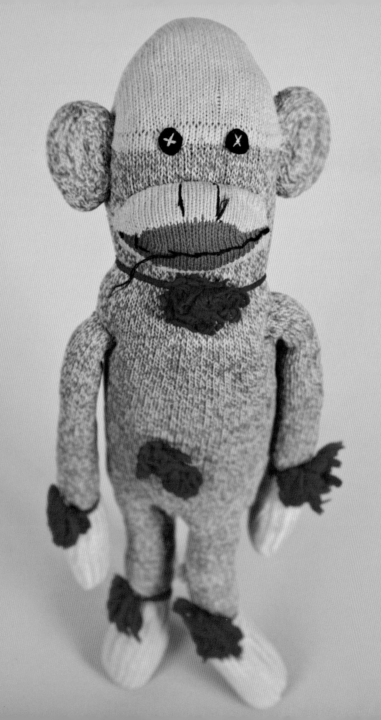

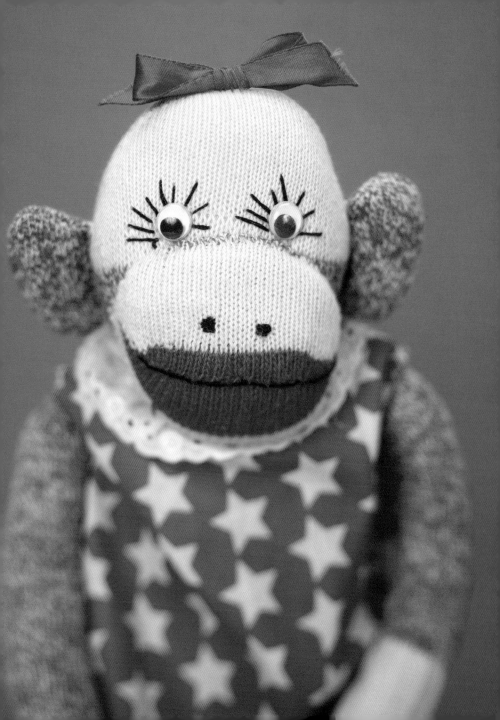

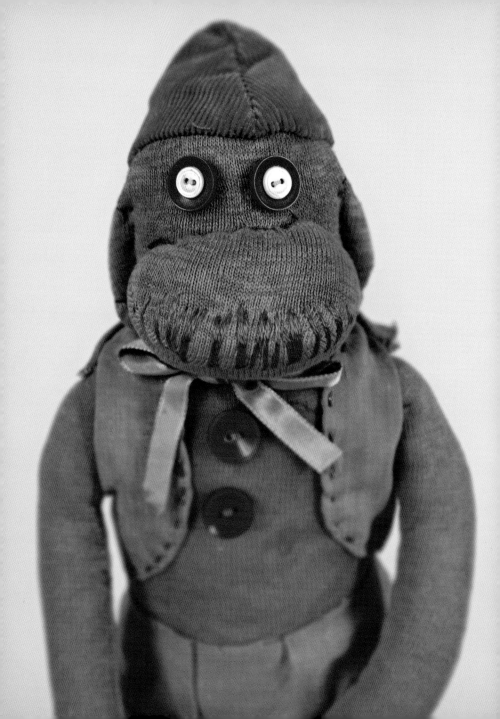

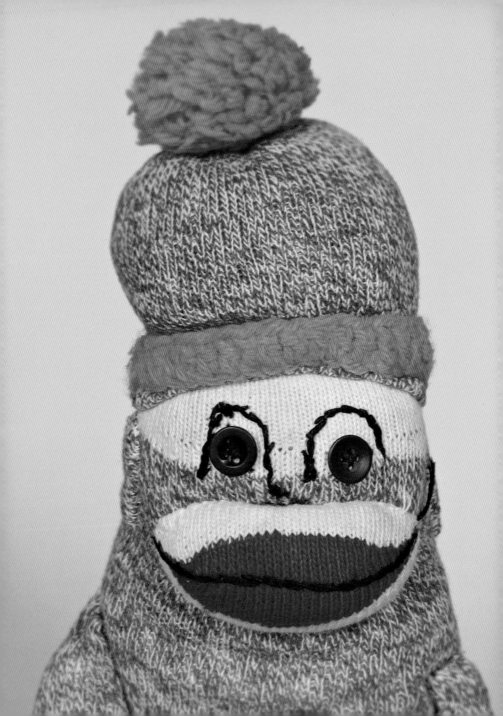

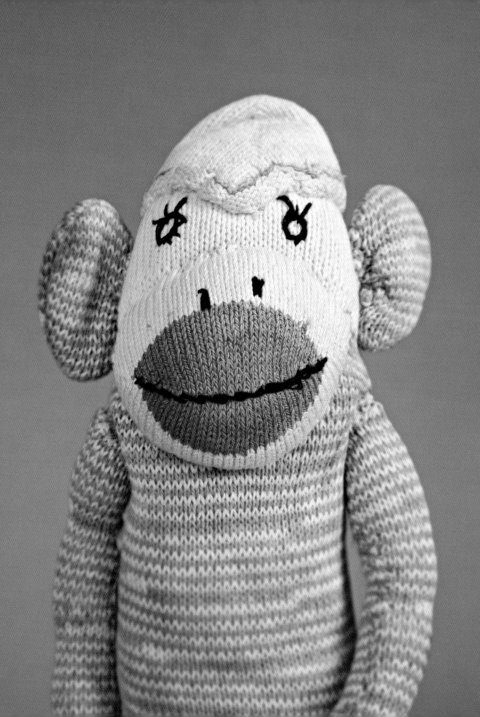

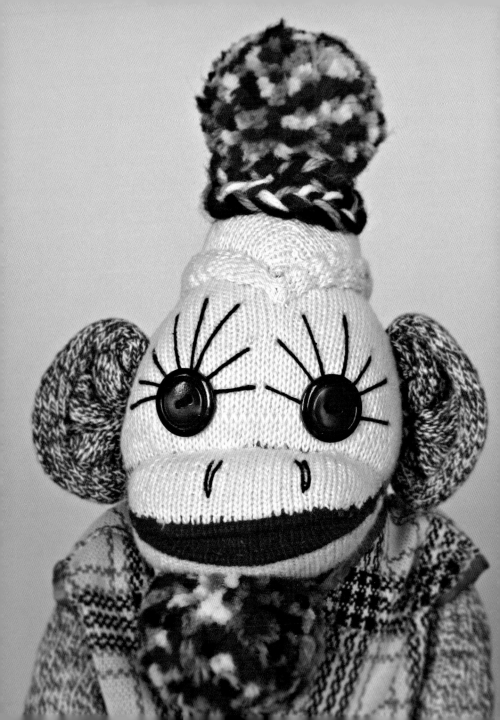

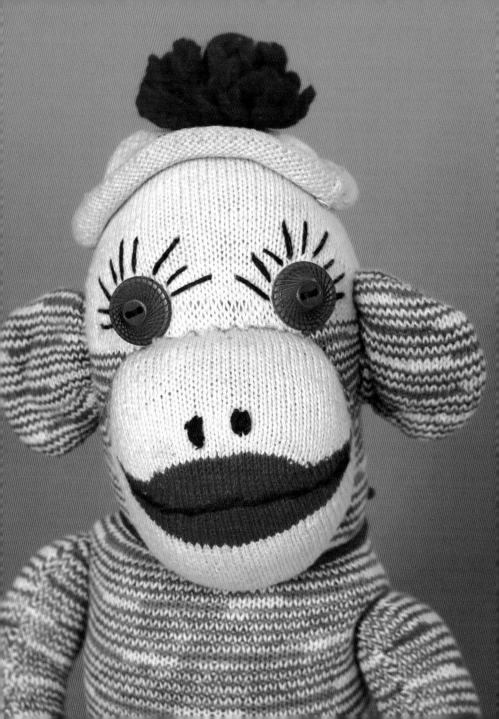

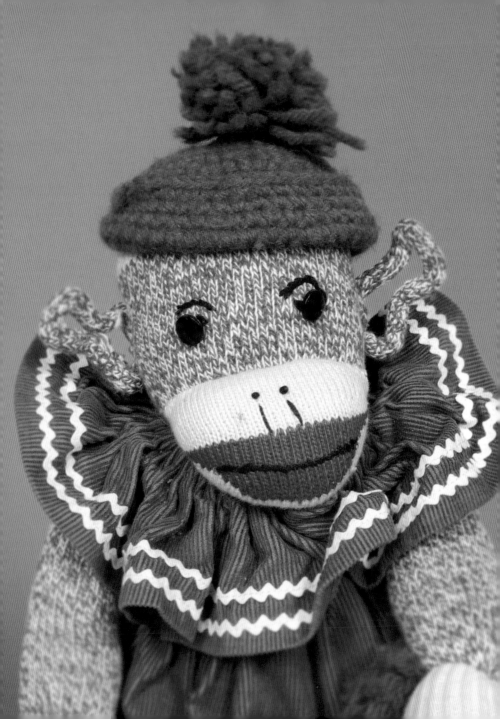

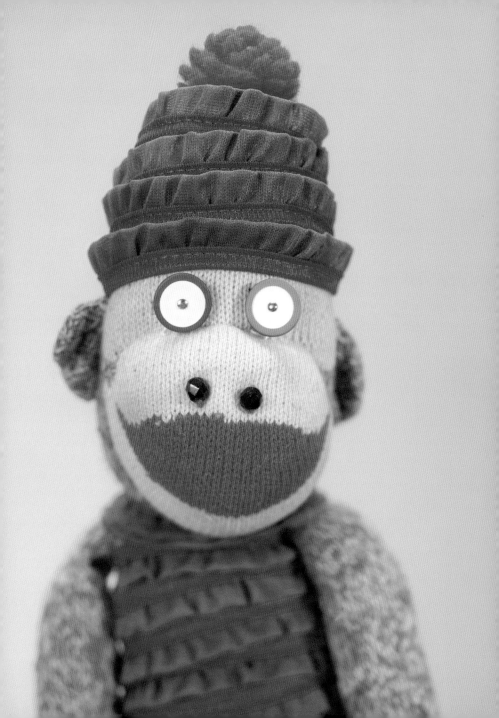

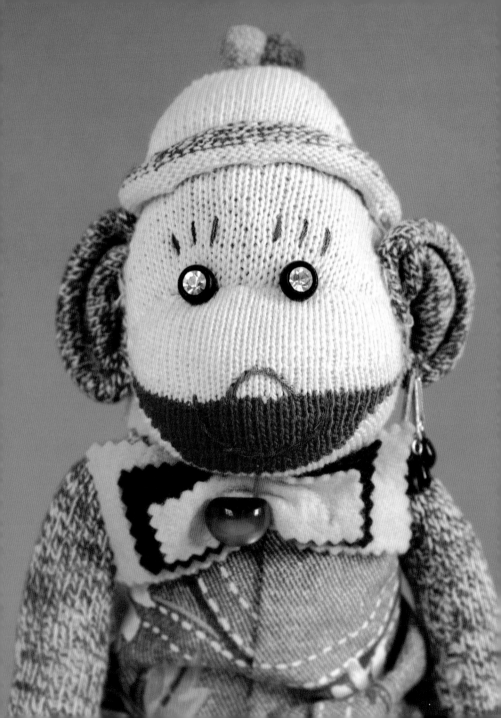

ARNE SVENSON is a New York–based photographer whose work has been shown extensively in the United States and Europe. He is the author of *Prisoners, Mrs. Ballard's Parrots,* and *Arne Svenson: Portraits,* and co-authored, with Ron Warren, *Sock Monkeys (200 out of 1,863)*.

RON WARREN vows he will one day live like Thoreau. Until then, he finds gratification in collecting contemporary art, mid-century design, Venini glass, sock monkeys, restaurant china, highway reflectors, orchid plants, river rocks, etc. He is a gallery director in New York City.

2008 teNeues Verlag GmbH & Co. KG, Kempen
Photographs © 2008 Arne Svenson
All rights reserved.

Photographs by Arne Svenson
Introduction by Arne Svenson & Ron Warren
Design by Allison Stern
Editorial Coordination by Maria Regina Madarang, teNeues Publishing Company

Published by teNeues Publishing Group

teNeues Verlag GmbH + Co. KG
Am Selder 37
47906 Kempen, Germany
Phone: 0049 / (0)2152 / 916 0
Fax: 0049 / (0)2152 / 916 111
Press department:
arehn@teneues.de
Phone: 0049 / (0)2152 / 916 202

teNeues Publishing Company
16 West 22nd Street
New York, N.Y. 10010, USA
Phone: 001 / 212 / 627 9090
Fax: 001 / 212 / 627 9511

teNeues Publishing UK Ltd.
P.O. Box 402
West Byfleet
KT14 7ZF, Great Britain
Phone: 0044 / (0)1932 / 40 35 09
Fax: 0044 / (0)1932 / 40 35 14

teNeues France S.A.R.L.
93, rue Bannier
45000 Orléans, France
Phone: 0033 / (0)2 / 38 54 10 71
Fax: 0033 / (0)2 / 38 62 53 40

www.teneues.com

While we strive for utmost precision in every detail, we cannot be held responsible for any inaccuracies, neither for any subsequent resulting loss or damage arising.

Bibliographic information published by Die Deutsche Bibliothek. Die Deutsche Bibliothek lists this publication in the Deutsche Nationalbibliografie; detailed bibliographic data is available on the Internet at http://dnb.ddb.de.

ISBN 978-3-8327-9244-2

Printed in China

teNeues Publishing Group
Kempen
Düsseldorf
Hamburg
London
Madrid
Milan
Munich
New York
Paris

teNeues

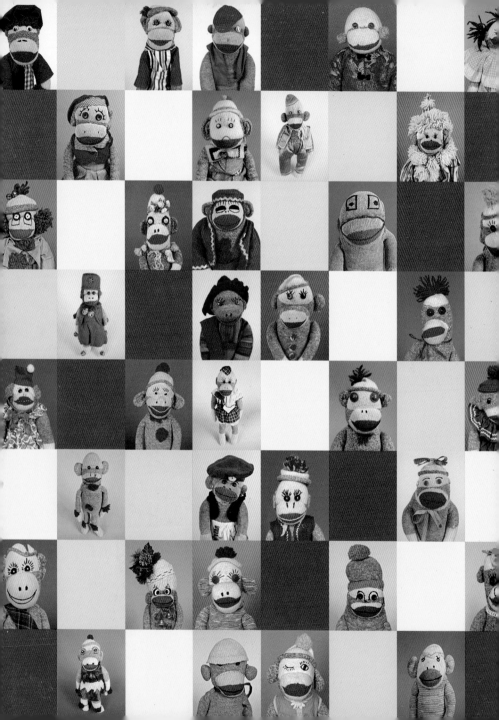